TRASH

TRASH

EDITED BY JOHN KNECHTEL

an ALPHABET CITY MEDIA book
THE MIT PRESS Cambridge, Massachusetts London, England

MIT Press books may be purchased at special quantity discounts
for business or sales promotional use. For information, please email
special_sales@mitpress.mit.edu.

Cover illustrations by Warren Heise
Endpapers and title page photographs—"Forest Floor," "T-Bay," and
"Snow"—by Robin Collyer (courtesy of Susan Hobbs Gallery, Toronto).

This book was printed and bound in China.

ISBN-10: 0-262-11301-5
ISBN-13: 978-0-262-11301-4
ISSN: 1183-8086

10 9 8 7 6 5 4 3 2 1

8 INTRODUCTION
John Knechtel

10 MORE FLUFF
Karilee Fuglem's photographs reveal complex worlds
within dust bunnies.

16 STREETS OF TRASH
Toronto trash flâneur Lisa Rochon wanders the streets,
shooting as she goes.

32 UNCLE FERNANDO'S GARBAGE TRIPTYCH
Priscila Uppal's poems portray her uncle, known in
Brasilia as "Dr. Garbage."

38 PLIEZ
Susan Coolen collects paper airplanes from the streets
of Montreal and other cities.

50 SAD CHAIRS
Gay Hawkins wonders what happens when
wasted things hang around, refusing to go away.
Photos by Bill Keaggy.

62 TRASHED SPACE
Nina-Marie Lister photographs urban waste spaces and makes the case for their reinvention.

76 IN | OUT
Braden King, Gariné Torossian, and Tigran Xmalian sort junk in post-Soviet Armenia.

90 THE HARBINGERS
In Nyla Matuk's fiction the year is 2029 and something is awry in China's zero-waste cities. Drawings by Derek Sullivan.

102 RECYCLING
Edward Burtynsky photographs recycling facilities in China and Ontario.

112 MESSAGE IN A BOTTLE
Mass-scale trash is the outcome of our economic system, argues Heather Rogers.

132 AIRSPACE
A photographic report by Pierre Bélanger describes the ecologies and economies of landfilling in Michigan.

156 MEDIA IN THE DUMP
Jennifer Gabrys reports on the residues from our digital devices.

166 DR. STRANGELOVE DR. STRANGELOVE
Kristan Horton recreates—in tiny trash assemblages—frames from the Kubrick classic.

196 THE ETHICAL ARTIFACT: ON TRASH
Trash marks the limits of knowledge, argues Barry Allen.

214 PROTOTYPES
Brian Jungen dissects and reassembles consumer products in order to simulate more ancient forms.

222 UTOPIA GLEANERS
Gleaners help us find the utopian energies of what has been cast aside, says Tina Kendall.

230 SOUND SUITS
Nick Cave's wearable artworks are built from found
materials and make sounds when animated by the wearer.

238 REFUSE/REFUSED
In Priya Sarukkai Chabria's poems the discarded—a worm,
an old woman, a shard of mirror—speak.

246 THE MISSING DAUGHTERS OF JUAREZ
Rachael Cassells travels to Juarez to photograph the
mothers of murdered Mexican girls.
Interviews and translations by Esteban Sheridan.

272 PLASTIKOS
Susana Reisman photographs the vacuum-formed
packaging used to display consumer goods.

280 SLOUGH
A poem by Mani Rao explores this corporeal premise:
"The new skins you grow are slough."

282 CONTRIBUTORS

Edvard Radzinsky's recent biography of Josef Stalin recounts how, in November 1917, the dictator strode into his richly furnished Kremlin offices for the first time and, spying an antique mirror leaning against the wall, cried, "Why all this upper-class luxury?" With one well-aimed kick of his black boot Stalin, who would later discard so many people in the Gulags, smashed his own reflection to pieces.

With every action, people make trash. Casually, as a matter of course, we throw things away. The concept of trash is the Midas touch inverted, and its malleability allows it to convert any thing or any one into garbage. People themselves—as testimony from the mothers of abducted and murdered girls in Juarez, Mexico, shows—can be made into trash. Lisa Rochon witnesses the human-to-trash shift at work on the streets of Toronto and asks: "When did our senses grow numb, overwhelmed by the parade of pain that moves constantly through the public realm?"

The ethical plea of trash is no less painful when it comes from objects–when we tune in to what Gay Hawkins calls "the strange experience of feeling sympathy for rubbish." Looking at Bill Keaggy's sad, charismatic chairs or Susan Coolen's found paper airplanes calls up our nostalgic connection to trashed things on their way to oblivion. "Everything falls back to coldness," says Wallace Stevens in "The Reader." Everything loses its lifeline to active economies and function. One response to this entropic pull of desuetude and deterioration, argues Barry Allen, is to design things that resist it: "The best trash is trash we are prepared to care for." His program for "morally sensitive" product design would minimize obsolescence and defer the trip to the dump.

One look at the dump—Pierre Bélanger's clinical dissection of a modern landfill site or Jennifer Gabrys's portrait of the toxic trail left by our digital technologies—demonstrates how effectively trash endures. It gets caught deep in geological structures, and there is more plastic than plankton swirling in the north Pacific Ocean. Everywhere trash is reproduced by the millions of tons and added to the mix. It extends into the future, beyond us. Or as Priscila Uppal writes, quoting her uncle, a sanitation engineer in Brasilia, "We'll be lucky / if anyone remembers us / as well as the earth / remembers our garbage."

We are embedded in our trash—there is no easy way to leap beyond it and build a utopia without garbage, to address the contradiction between the world's limited resources and our seemingly unlimited ability to manufacture trash. Its production is rooted in survival, represented in every culture, and magnified by economic success. To purge the earth of garbage would be to destroy our own reflection.

—JK

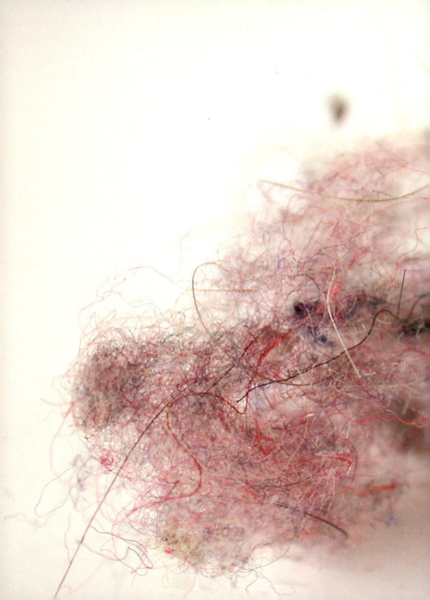

MORE FLUFF

Karilee Fuglem's photographs reveal
complex worlds within dust bunnies.

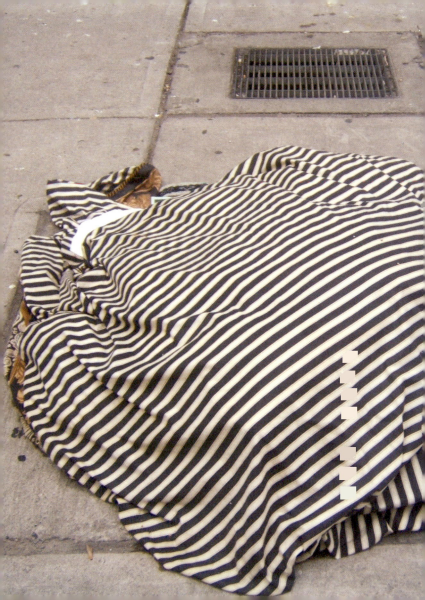

STREETS OF TRASH

**Toronto trash flâneur
Lisa Rochon wanders the streets,
shooting as she goes.**

We trashed the place the other night. Her and I.
She wore a gaudy, trashy dress with holes in her stockings.
Whenever she spoke it was complete garbage—
"Is not," she whined, totally trashed. "Get me my smokes."

There is much absurdity thrown up on the sidewalk. Construction debris, toilets, chairs, doors, garbage in misshapen green plastic bags. Piles of sleeping bags, a diary, a tidy plastic bag of Oreo cookies. Human beings.

A place for the flâneur to wander in a state of careless distraction? Hardly. Grab a shopping cart and start maneuvering your way through the debris.

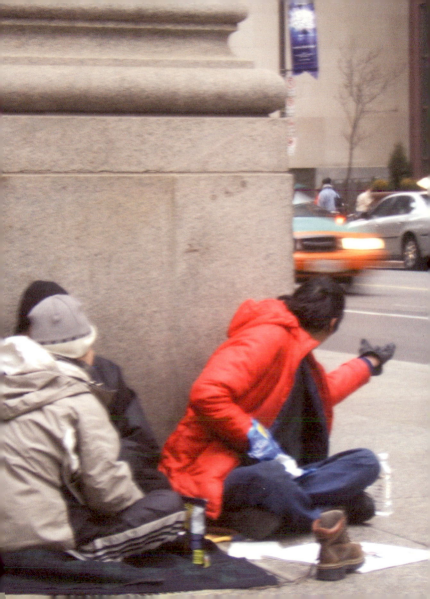

Turtle Island
RECYCLING
(416) 406-2040
www.turtleislandrecycling.com

Sprawl trashes. And trash sprawls, devouring the sidewalk. This public space, which in postgraduate urban design courses we thought of as strictly reserved for mailboxes and benches, lamp standards and recycling bins, is actually ruled by the startling, insidious demands of trash. People lie down on the sidewalk, drawing heat from the city's underground, seeking shelter from the wind behind a granite bank building. Strange cohabitations occur—a recycling bin dwarfed by glittering corporate towers, two-by-fours thrown onto a traffic median, and piles of sleeping bags, how soft they look—like Renaissance drapery—against the wrought iron fence of a downtown church. On the other side of town, there's a striped duvet that's been floated down on the pavement. Once upon a time, it adorned somebody's bed and looked beautiful. There on the street corner, that blanket is fluffed with lies and deceit—Job's comforter.

As a seventeen-year-old newly arrived in Paris, I looked down from my third-floor apartment, and saw a beaten-up mattress with a lamp next to it. There could be no argument about its position on the sidewalk—the mattress was clearly, deliberately occupying center stage. It was my first experience of garbage and human beings in an unsettling co-existence. Nighttime: looking down from my window, I saw a man with a white beard curled up on the mattress. That summer night, he appeared to be wearing cotton pajamas. Such was one man's attempt to maintain a sense of domestic decorum even while living in the wilds of the sidewalk. I've never encountered a lamp that held so much sadness.

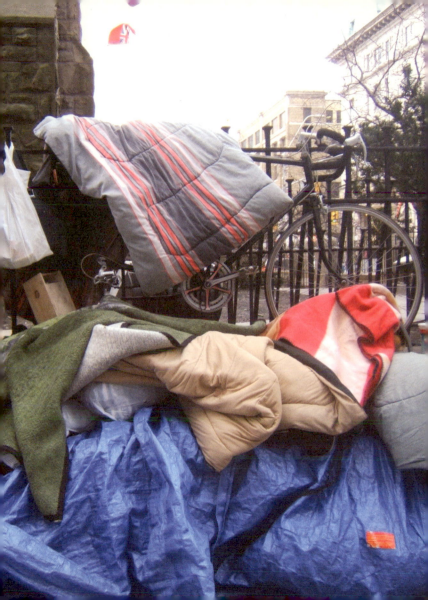

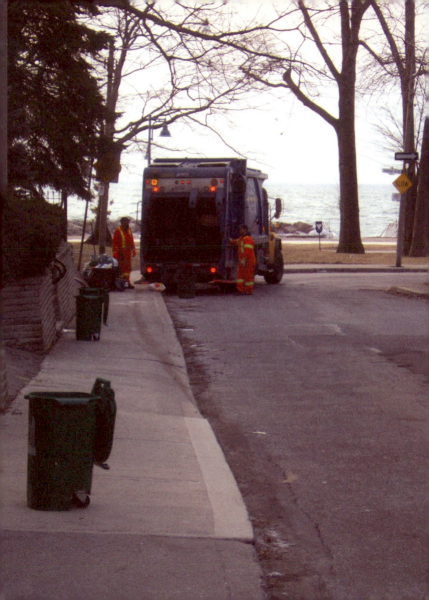

How to package garbage, and make it less offensive, has become the latest design challenge. Toronto, like so many other cities, has issued green recycling bins. On garbage day, they're lined up on the sidewalk like little green men. There are smaller containers for under your kitchen sink to catch your raw fruits and vegetables. Decomposing paper bags are required for your autumn leaves. Dog poop must be scooped from the sidewalk and the beach. Apparently, trash has been contained. But nothing could be further from the truth. Trash seeps out a little more every day.

We've adjusted our eyes to the crap on the sidewalks. Placing a toilet in the lobby of your office is unacceptable—but position it outside and there's no shame. Frank Gehry contends that a debilitating impoverishment happened decades ago when chain-link fence and corrugated metal proliferated, demarcating schools, tennis courts, and highways. Only when Gehry wrapped his Santa Monica house in layers of the metal hardness did people pay attention.

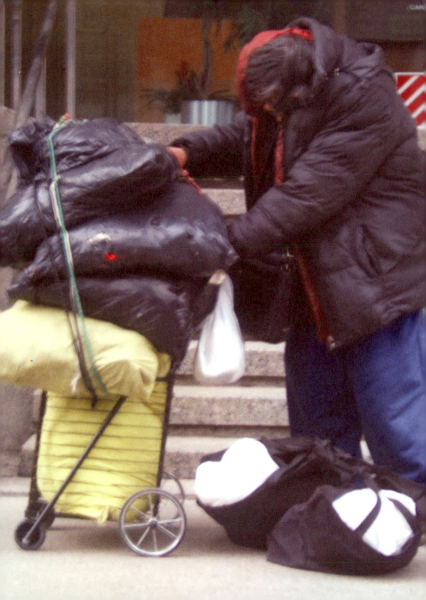

When did our senses grow numb, overwhelmed by the parade of pain that moves constantly through the public realm? Was it during the aerial bombardments of the Second World War when entire cities were ripped apart? Was it when American blacks stood in a separate line at the bus stop? Did we grow hard with the 1989 slaughter at Tiananmen Square?

It's not that we've lost the ability to feel for the trash that lies scattered on the ground. We've simply innovated coping mechanisms. Such as stepping around bodies huddled on the ground. Leaving a sandwich by the emaciated body of a crack addict. Throwing some coins into a paper cup. Last year, on a freezing winter's day, there was a small shape lying on a grate; so small was this person, with hair cropped short, I thought I had come across a boy. In fact, she was a woman, maybe twenty, with startling blue eyes. She accepted my invitation to lunch and we drove to her idea of a perfect restaurant: Mr. Sub. In the minus 10°C cold, she wore beach sandals and socks. She refused to go to a shelter or a hospital, but shopping held considerable appeal. We found a Salvation Army and, though she was strung out on crack and sucking with quiet desperation on a baby's soother, she became a regular girl during that shopping spree. Together, we dug through boxes of footwear and showed each other what we had found. I recommended a pair of warm boots. But trashy silver platforms were what she discovered, and what she wanted. She put them on and walked out of the store. We parted ways on the sidewalk, where all is forgiven and excused.

UNCLE FERNANDO'S GARBAGE TRIPTYCH

Priscila Uppal's poems portray
her uncle, known in Brasilia as
"Dr. Garbage."

MISPLACED ANGER

When you're angry with someone,
Fernando insists,
never call him garbage.

Anger is nothing to garbage:
garbage eats anger for breakfast.
It eats all of us in the end.

And we'll be lucky
if anyone remembers us
as well as the earth
remembers our garbage.

YOU GO TO THE MOVIES

Three times Uncle Fernando's neighbors
have called the police to report him.

When they go to the movies,
he goes through their garbage.

How is this a crime? he argues.
The stuff is right here, out on the street.

I don't steal it. I just look. It's my job. The police
eye him warily (Fernando is a big man

with large eyes and cancer scars, and a certified
garbage expert), let him go with another warning.

My fellow creatures have no idea the service
I'm providing, he assures me, as I note

down the contents as he calls them.
You learn much about the world from

its garbage. I nod, plug my nose. I know
he is highly respected in his field, but

this is not the way I imagined my vacation.
Pronto! he cries. *Soon they'll be back from the movies*

with all kinds of strange talk and ideas in their heads.

MY UNCLE PARACHUTES INTO GARBAGE

This is the funniest family video I have ever seen.
Grandmother sits quietly, sipping watermelon juice
while Aunt Victoria serves tiramisu
and tea, and outside a monkey swings from the tree.

One Two Three

Uncle drops out of the sky like a giant fly.
Long arms and legs extend out against the shiny window
of the clouds. On his back, Daffy Duck gives us all the finger,
and I laugh, but no one else does. Grandmother shrugs;
Victoria confers with the servants.

Why Daffy Duck? I ask.
Palotino, my uncle replies, in Portuguese.
Daffy's like me. Like how I wish to be.
No wife. No children. No family.

Now his wife laughs. And my cousin Fernanda.
Loco, his wife announces. It's the first word she's said
to me since I've been here.

This is my family. The Brazilian family
that I haven't seen in over twenty years.
My DNA is in that airplane. My past
dangles on that branch. My death might
be curdling on the milk.

The screen wiggles for a second. Then—
blank. My uncle shrugs. *I landed*
right in there—right in the middle of the trash—
I couldn't have planned it any better.

He snags the video out of the machine,
sits down for ice cream. But my mind is still flying
with him, dropping out of sight,
and past all known geography
into a future family photograph
on Aunt Victoria's mantel
beside her porcelain bells and liqueur glasses
and a bright orange broken bird's beak.

PLIEZ

Susan Coolen collects paper airplanes from the streets of Montreal and other cities.

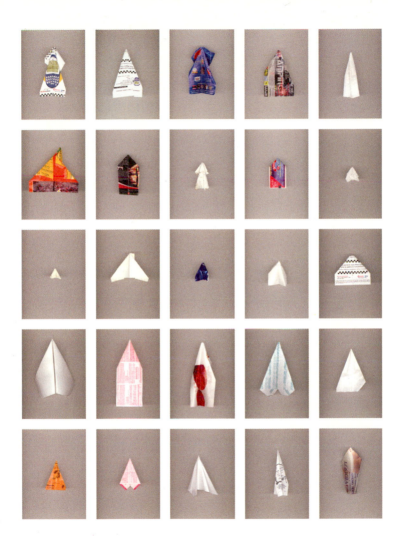

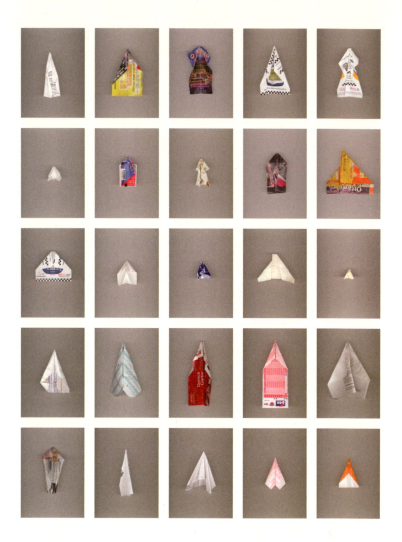

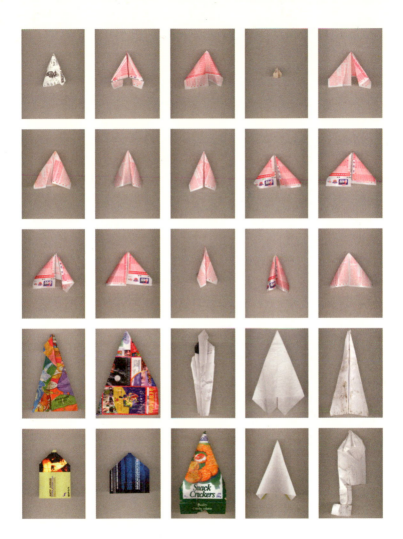

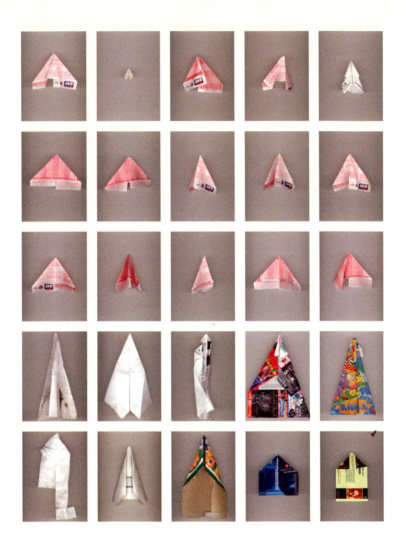

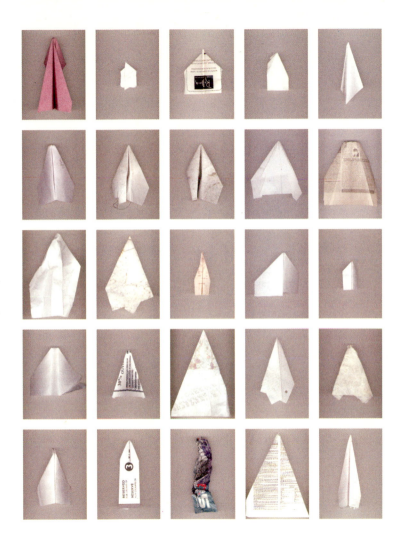

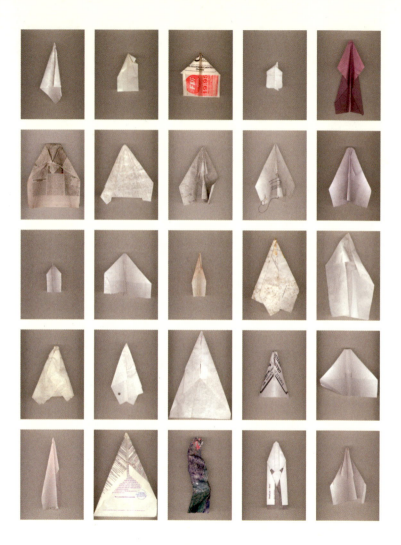

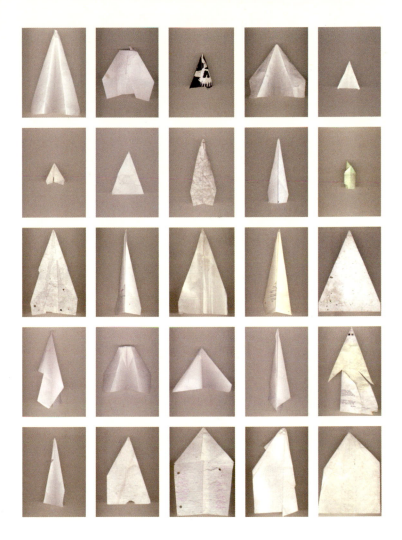

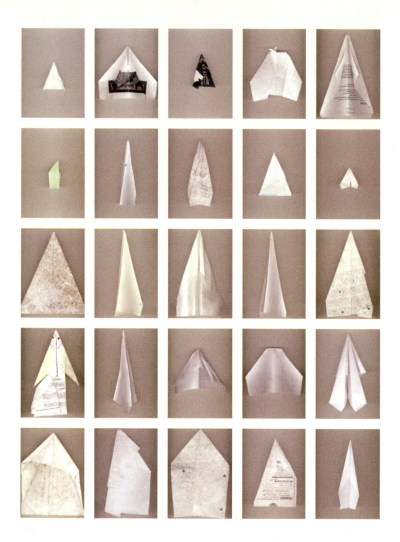

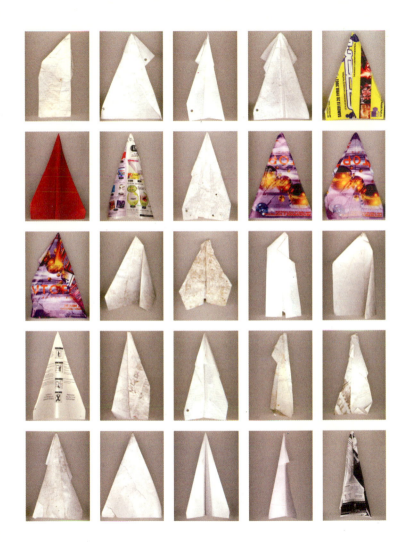

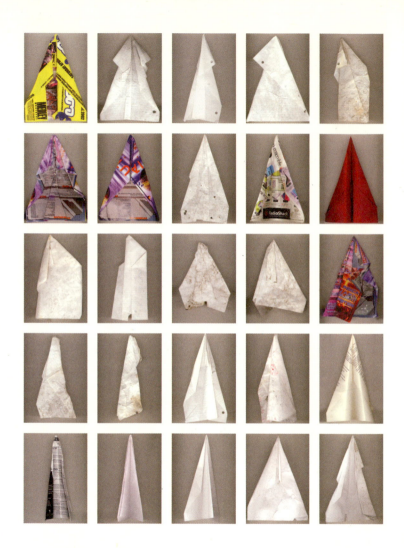

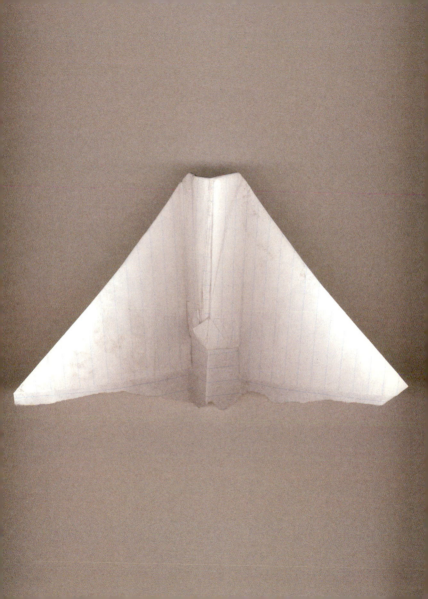

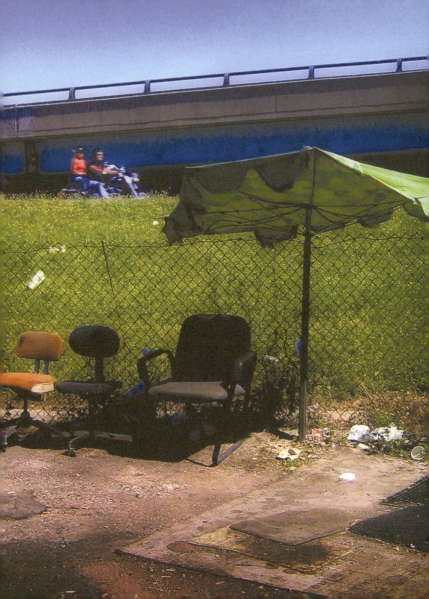

SAD CHAIRS

Gay Hawkins wonders
what happens when
wasted things hang around,
refusing to go away.
Photos by Bill Keaggy.

50 SAD CHAIRS BY BILL KEAGGY

1. ORIGINAL

2. LOADING DOCK

3. BOOTH

4. JUNKYARD

5. SHADE

6. TRUCK

7. WET ALLEY

8. PLASTIC #1

9. IMO'S

10. WET CAR SEAT

11. ONE FOLDING

12. OFFICE

13. THREE FOLDING

14. WHITE

15. SOFA

16. TOILET #1

17. TOILET #2

18. DESTROYED

19. BLUE

20. BREAK AREA

21. CAR WASH #1

22. CAR WASH #2

23. PHONEBOOTH

24. DOORSTOP

25. SIDEWALK

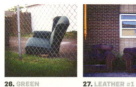

26. GREEN **27.** LEATHER #1 **28.** FOR SALE **29.** OFFICE **30.** GARBAGE

31. STACKED **32.** STADIUM **33.** PLASTIC #2 **34.** PLASTIC #3 **35.** FREEWAY

36. BACKYARD #1 **37.** FIELD **38.** PINK **39.** RECLINER **40.** CEMENT

41. STRIPES **42.** BRANCHES **43.** UPSIDE DOWN **44.** MOTORCYCLE **45.** MULTIPLE

46. PILE **47.** WEEDS **48.** BACKYARD #2 **49.** LEATHER #2 **50.** BRIDGE

If you go to Bill Keaggy's extensive website, keaggy.com, one of the things you'll find is a photo collection called *50 Sad Chairs,* a record of his everyday encounters with chairs out of place. These aren't obedient chairs clustered around a dining-room table or lined up behind desks. Some have been dumped with other garbage or abandoned in the street. Others are barely clinging to life: still in use, but only just; they look like gleanings from someone's trash, given one last chance at active service behind a car workshop or on the front porch of a run-down house.

As you move through the collection you encounter fifty chairs, of every variety, in fifty different settings. There is a broken hot-pink recliner nestled up against a dumpster, accompanied by Keaggy's comment: "I wonder what they did that broke this recliner in half?" (no. 38). There is a wrecked wooden dining-room chair lying on its side next to a sidewalk, with weeds growing through it. Keaggy observes: "A rolling chair gathers no moss?" (no. 47). In a backyard, a mixed assortment of chairs (plastic, stackable, dining-room) are grouped around a barbecue (no. 48). A checked sofa covered in dead weeds sits next to a dumpster, surrounded by plastic bags, empty fast-food packaging, and other street detritus. The image is accompanied by three words: "Dirty, dirty, dirty" (no. 42).

I love this collection. Like all great collections it animates things by putting them into new relations and classifications, allowing us to see them in unexpected ways. But what are these new relationships? How have these trashed chairs been reclassified? Keaggy gives us a clue in his title. By calling this collection of chairs "sad," he invites us to feel something for trash. He makes wasted things visible by reframing them as lost and abandoned. This new way of emotionally framing discarded things is unsettling in a number of ways. For a start, it forces us to notice what we are usually blind to, the shit

end of capitalism, the part we don't want to see. Trash is the part we like removed and disappeared as efficiently as possible; when it hangs around there is a chance we'll be reminded of the ethical and ecological consequences of constant accumulation.

Then there is the question of affect, the strange experience of feeling sympathy for rubbish. Most representations of waste frame it as the bad, environmentally destructive stuff that we've been trained to hate and fear. The garbage of modern life has no meaning except as objects wrecking nature. Yet here, with these images, a different feeling takes over, a melancholy that forces us to notice abandoned things and feel for their plight. Suddenly, it's not nature we feel concerned about but these forlorn chairs. Most of them are dead or dying; they've been captured at the point when they've run out of value, and not just as a result of material decay—many are still functional—but because, for whatever reason, they have been rejected. A single dining-room chair sitting by the sidewalk is a poignant reminder of all those years when it was used by persons unknown, showing us how human use, by giving or withdrawing instrumental status, is crucial in making objects materially meaningful.

Yet even though the sadness of these chairs is a testament to our unthinking abandonment of items we once valued, there is something about them that exceeds that interpretation: for me, the most powerful effect of the *50 Sad Chairs* collection is the way it captures the material recalcitrance of trash, its lingering presence, its refusal to go away. Bill Brown describes this aspect of materiality as thingness. According to Brown, we glimpse *thingness* in irregularities in exchange circuits, in moments when objects stop working for us, or when we are not quite sure how to identify them: he could easily be describing the essential quality of Keaggy's chairs (4–5). When objects assert themselves as things, when things provoke and incite, when they

capture our attention and demand to be noticed, we experience the anterior physicality of the world as a sensuous presence in a way that exceeds our usual daily relation with the objects we use. And in these chance interruptions, these occasions of contingency, as Brown calls them, different relations surface: "the story of objects asserting themselves as things, then, is the story of a changed relation to the human subject and thus the story of how the thing really names less an object than a particular subject-object relation" (5).

Theories of material culture focus on the role of circulation and use in the creation and destruction of value: they illuminate the human and social contexts of objects in motion. But what happens when objects stop moving, when they are abandoned, stuck out on the sidewalk, turned into urban debris, or dumped at the tip? This is when Brown's thing theory comes in handy. It explores how the latency of thingness can surface when objectification breaks down. The thing is always a kind of remainder, even when it is still in use, and so too, even more strikingly, is trash. Hence the potential of trash to remind us of the liminality between useful and useless, humble object and recalcitrant thing.

In capturing the moment when "objects assert themselves as things," Keaggy shifts our relations to trash. He doesn't just make us notice trash; he also, inadvertently perhaps, gives it agency. Rather than being the bad object of environmentalism or the stuff we pretend not to see, trash is recognized as having a force or vitality that resists, or exists beyond, its imbrication with human subjectivity. The effect of this changed relationship between us and our trash is significant. Keaggy, in *50 Sad Chairs*, shows trash *making a claim on us*.

What might we learn from such unexpected encounters with the materiality of trashed things? Could these experiences of trash as matter alter our understanding of the distinction between human and

nonhuman, or dead and alive? And might these encounters suggest different ways of living with waste, different material practices?

I think that when trash claims our attention and demands to be noticed the interaction is one that makes an ethical claim on us. The experience entangles us in new networks of obligation, and makes us reconsider our ways. *50 Sad Chairs* has this effect: it suggests a radically different approach to environmental ethics. Rather than making us feel sympathy for an abstract and sacred "environment"—nature under threat from mountains of trash—*50 Sad Chairs* invites us to think about our relations with things. It widens the focus of an ethical response to planetary degradation, allowing us to consider also the social lives of commodities. Of course, environmentalism has always been concerned with commodities, but usually in ways that involve moralistic critiques of over-consumption and wasteful disposability. The problem with this approach is that it easily breeds resentment, guilt, or a paralyzing sense of personal anxiety about one's role in the destruction of nature. Or environmentalism can take a political position, letting the consumer off the hook but railing against the capitalist excesses of corporations that produce commodities nobody needs. I don't disagree with these critiques, but I worry about their effects, particularly the way they close off other sorts of ethical responses. Moralism and blame have never been good motivators for political change.

The problem with environmental critiques of commodity culture is that they assume a clear separation between culture and nature. No matter how they configure the relation between culture and nature, they are seen as ontologically and materially distinct from each other. This dualistic thinking inhibits any serious consideration of the specificities of trash and our relations with it. It posits fixed, separate identities for nature and culture, identities that have to be

protected to remain pure. In the opposition of humans to nature, trash functions not as what undoes or denies this opposition but as what contaminates both sides. Our capacity as humans to destroy nature with our trash reveals us as morally bankrupt, while the capacity of nature to function as a dumping ground defines it as passive and defiled. The destruction of paradise happened not when Adam took a bite of the apple but when he dropped the core on the ground.

Trash can only ever be bad in this framework. It is the destroyer of the purity of both sides in the conflict between nature and culture. It is the thing that has to be eliminated in order to re-establish the essential identity and difference of each category. This tendency to blame trash uses a moral framework to explain the effects of destruction and contamination. Trash makes us feel bad. Its presence disgusts and horrifies us; it wrecks everything. In these familiar sentiments badness is located in the object that disrupts purity rather than in the relation between the person experiencing the unpleasant affect and the object that causes it. In the quest to purify, which Bruno Latour describes as a typically modern strategy, waste has no generative capacities, only destructive ones (10–12). No wonder it is so easy to place trash at the center of our anxious scenarios about the collapse of purity and the end of nature.

Yet, as Latour also argues, purification goes hand in hand with the rise of "translation," the emergence of hybrid categories that are mixtures of nature and culture. The more we demand sharp distinctions between nature and culture, the more inevitable it becomes that an increasing number of things will not fit easily into either category. Could we think of trash as evidence of translation, as part of this proliferation of hybrids? It certainly shows us how ambiguous the boundaries between culture and nature are, how everything contains elements of both. The abandoned chair rotting quietly in the

landscape is alive with the activity of decay. It has become a habitat; it looks both sad and perfectly at home. The shifting and contingent meanings for trash and the innumerable ways it is produced reveal it not as essentially bad but as subject to relations. What is rubbish in one context is useful and valuable in another. Different classifications, practices, and uses place differing emphases on the varying material qualities in things and persons, actively producing not only the distinction between nature and culture but also the difference between a waste thing and a valued object.

50 Sad Chairs is not a moral critique of trash and its shocking effects. Rather, it raises its ethical questions by its iconic evocation of Latour's notion of hybrid categories and "naturecultures": how a dense web of networks and connections binds us to things and how we are caught up with commodities long after we dispose of them. This sense of complicated interactivity disrupts clear boundaries between persons and things, and between nature and culture. It shows that these categories are constantly changing and slipsiding into each other in new and surprising ways. And this is where the ethical force of trash lies, in its ability to provoke and excite: to pose questions that challenge us to live differently.

The effect of *50 Sad Chairs* is to open up a very different way of thinking about and living with trash. Moral instruction about the "waste crisis" is not the intention of this collection. Rather, Keaggy's images recognize a potency in trash that makes it much more than just the bad result of our environmental destructiveness and consumer excess. Instead, his trash becomes a relation in which we can see the force of conversion and transience, and sense other uses and possibilities emerging. His sad chairs are enchanting and disturbing. They trigger the ethical imagination in all sorts of ways. Not simply by seeing how people glean and make do with trash, giving it new

uses and new life, but also by inviting us to think about our own interactions with things. Constant serial replacement is the backbone of commodity culture. In documenting where things end up once we've chucked them, Keaggy disturbs our comfortable belief in "out of sight, out of mind." Trash is way too recalcitrant for that kind of fantasy.

Bill Brown (2001)
Thing Theory
Critical Inquiry 28

Bruno Latour (1993)
We Have Never Been Modern
Cambridge: Harvard University Press

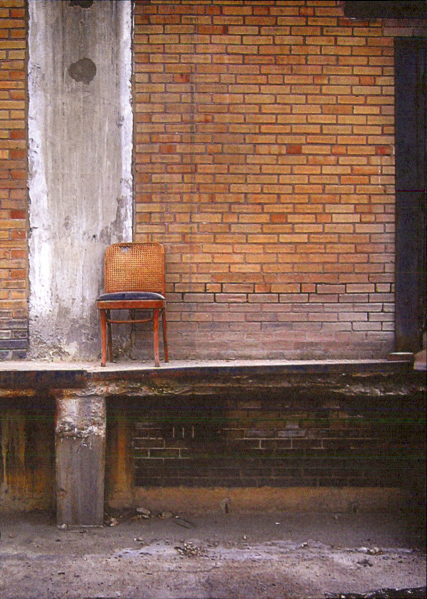

TRASHED SPACE

Nina-Marie Lister photographs urban waste spaces and makes the case for their reinvention.

"Junkscape" is what the writer and anti-suburbanite James Howard Kunstler calls them. Urban activists and cynics call them "waste places"; academics call them "postindustrial space"; and the community planner Pamela Robinson has memorably named them "crudscape." The abandoned or overlooked landscapes of the contemporary city are variously over-used, under-used, and abused. They are the forgotten planes of space in the metropolitan landscape that over 80 percent of Canadians now call home. What do these neglected areas mean for the people who live with or near them? Are they trash—mere litter, the flotsam and jetsam of the city, part of the cost of urban living, doomed to be unofficial dumps for consumer society's detritus? Or are junkscapes potentially good, productive places, waiting for someone to reconsider, reclaim, and recreate them as a worthy part of the urban landscape?

The term *junkscape* is used here to mean space that is literally being wasted: space within the landscape that is no longer functional, or has never been productively used. Implicit in this idea is *potential*: spaces that now lie dormant can and should be seen as awaiting reactivation through some new creative reuse. In the contemporary urban domain this kind of space is, by definition, a human creation, brought into being deliberately or inadvertently by planners, industry, or other land users. Many waste spaces are direct products of extraction and use, postindustrial and often contaminated areas remaining after whatever resource they contained has been exploited; others, such as the massive roof spaces of big-box retail centers, are the indirect products of modern building or planning. Dolores Hayden has compiled an emerging vocabulary and nicknamed typologies for these spaces in her *Field Guide to Sprawl*. For example, "TOAD" is an acronym used by planners to refer to a temporary, obsolete, abandoned, or derelict site, which could include abandoned

JUNKSPACE

Two examples of junkspace that is no longer functional, ecologically or economically. In the urban domain this kind of space is, by definition, a human creation, brought into being deliberately or inadvertently by planners, industry, or other land users.

TWO TYPOLOGIES OF WASTE SPACE
The site above is referred to as a "TOAD," an acronym used by planners to refer to a temporary, obsolete, abandoned, or derelict site. The site below is known as "mall glut," large shopping malls with vast parking areas.

shopping malls, empty warehouses, or closed industrial sites. A TOAD might also be the site for "ground cover"—developers' slang for cheap, easily bulldozed architecture (such as storage units, or a model-home sales center) that temporarily occupies a site until the owner finds a more profitable use for the land. Similarly, "mall glut" refers to the growing problem of unsustainable retail malls in the United States, which has twice the square footage of retail space per citizen than any other country. For example, an increasing number of US shopping malls, along with their vast parking areas, are simply being abandoned each year, as ever-bigger regional malls, more big-box discount stores, and online shopping draw hungrier consumers away (46, 66, 106).

Directly wasted spaces are the leftovers of our once-prosperous industries and retail endeavors. Abandoned railway lines, warehouses, docklands, manufacturing sites, factory yards, and empty shopping malls now lie exhausted, spent, and broken. Economically finished, socially forgotten and ecologically decaying, they are wasted remnants of what was, or what could have been, in a culture other than one defined by endless consumption and planned obsolescence. Today, the worst of these spaces are variously termed brownfields, postindustrial areas, extreme sites, or manufactured sites (Gans and Weisz; Kirkwood). These sites were indeed, in every sense, manufactured creations of a human economy that used them as long as they were workable and profitable, then simply walked away from them, leaving them physically, legally, and economically to become someone else's problem.

The other kind of waste space that occurs in our cities is an inadvertent byproduct of "progress" and development. To this category of space we are effectively blind; we do not see it, and it does not register as anything other than a non-functional by-product of the

urban condition. Specifically, these are the vast and monotonous roof-scapes of our urban and suburban retail and commercial buildings. Yet if we consider that our already scarce prime agricultural land is being lost to urbanization in Canada at an unprecedented rate, void rooftops become palettes for possibility. For example, Germany has the world's largest number of residential, municipal, and corporate rooftop gardens, used for everything from more efficient insulation to recreation to food production (Dunnett and Kingsbury). Urban poverty should compel us to legislate the conversion of standard roof ballast to rooftop gardens as a measure of increasing food security—a notion that is attracting interest in many cities, including Toronto. In other global cities and city-states—including Hong Kong, Singapore, and Monaco—high urban density, inflated land prices, and the extreme scarcity of usable space within city limits have resulted in the passage of laws stipulating that roofscapes must be accessible and functional. In arid regions, or those where fresh water is in short supply, rooftops are routinely used to gather, store, and conserve water.

Whether rejected because of postindustrial contamination or ignored because of rooftop isolation, these waste spaces are never truly dead. Roofscapes gather water, like it or not, and winds bring in soil particles and seeds of every description. These constructed planes are not barren, but full of fertile potential. On the ground, even in the most toxic sites, life exists and persists, often with amazing tenacity and resilience in the face of total contamination: in Sudbury, Ontario, for example, heavy-metal-tolerant grasses have evolved in the polluted shadow of INCO's enormous nickel mines and smelters. Yet despite the adaptive species that can and do survive in these waste spaces and others that may eventually colonize them, they are places that appear to us to be dead or—to the optimists among us—peopled by ghosts; they evoke ambiguous memories of what they once were.

ROOFSCAPES

are the non-functional byproduct of the urban condition. Two aerial
views of the vast and monotonous roofscapes of our suburban industrial
and commercial buildings.

Indeed, these apparently desolate spaces are much more than they appear on the surface. The late architect Ignasi de Solà-Morales Rubió found rich meanings in the French term *terrain vague* which he borrowed to describe, in exquisite detail, the paradox that emerges from the abandoned, residual spaces of modern urbanity: "void, absence, yet also promise, the space of the possible, of expectation" (120). In contemplating the wastelands of post-Ford Detroit, Daskalakis and Perez also invoke the notion of *terrain vague* to articulate the "illuminated erasure" of place that suggests at once the presence of an absence, and the absence of a presence. What appears initially to be waste space is not a mere *tabula rasa* for an ecological revival, but rather a palimpsest, awaiting its next reinvention. These are perhaps better seen as places-in-waiting.

In this sense, the postindustrial waste places of the urban landscape have already captured the imagination of urbanists, artists, and landscape architects. For example, Julie Bargmann's D.I.R.T. Studio celebrates "Toxic Beauty" in reinterpreting some of the worst of the United States's Environmental Protection Agency's Superfund sites, that is, postindustrial sites, such as mines and refineries, that qualify for federal clean-up funding on the basis of extreme contamination. Bargmann is a staunch advocate of celebrating a site's history through landscape architecture that remakes the site using elements of the former industry, either real or symbolic. Similarly, Peter Latz & Partners, landscape architects, are renowned for having reincarnated industrial Germany's heartland by giving new life and meaning to the postindustrial Duisburg Park in the Emscher region. Here, Latz has integrated culture and nature in a way that speaks to both past and present activities, fading and emerging ecologies. Storage tanks have been cleaned and filled with fresh water for scuba diving, while gasification plants and their smokestacks are used as platforms

for scaling and rappelling by rock-climbing enthusiasts. By using the decaying brown coal bunkers as the infrastructure for a formal botanical garden, surrounded by a naturalized perimeter, Latz pays homage to the industry that sustained generations of miners and their families, while offering new opportunities for recreation, regeneration, and reflection.

RECLAMATION OR REINVENTION?

Artists and designers are fascinated with waste spaces, using them in constructive and ingenious ways. Yet in conventional planning and landscape architectural practice we still treat these sites as hopeless. We see them as desperate candidates for salvation, which we offer through a standard and simplistic "clean-and-green" approach, erasing any trace of the site's offensive past and replacing it with virtually anything living and green. This off-the-shelf remedy is routinely disparaged by Kunstler as a "nature Band-Aid," where plant materials are unceremoniously plunked around a site or building as haphazard decoration, with no discernible site function or legible connection to place. Worse yet, regreened sites such as capped landfills, closed dumpsites, or exhausted mines are often only superficially altered. Despite our best intentions, contamination is usually invisible, lurking underground and never truly contained, emerging later or migrating elsewhere through groundwater flows. Regreened sites are usually used primarily for recreation purposes, as generic playing fields or unprogrammed "parks" composed of ordinary, ubiquitous plants that tell the passerby nothing about the site's architectural, ecological, or cultural history. The result is little more than green-wash. While perhaps pretty in a pastoral sense, paving our past with sod is both dangerous and meaningless; it is a fitting companion to

urban sprawl, a homogeneous landscape that is as uninteresting as it is vapid.

Increasingly though, there is one way of regreening waste spaces that can serve an important ecological function, with potential cultural benefits as well. Witness the hundreds of local environmental groups across North America that are striving to "bring nature back to the city." These groups are dedicated to ecological restoration, naturalization techniques, and other generic "greening" initiatives to increase local biological diversity in urban areas: Toronto's accomplished Evergreen Foundation, for example, has been very successful. Many cities' parks and recreation departments now have policies like Toronto's in place, encouraging the use of native plants rather than more environmentally costly exotic or ornamental species that would displace and disrupt the local ecology. Such initiatives are effective in restoring some of the native biodiversity to otherwise denuded urban areas, and they may also improve our collective ecological literacy through increasing citizens' engagement in the reuse of waste space.

Despite these benefits, an ecological approach to regreening waste space is not a panacea, nor is it always good planning or the most appropriate design. In the worst cases, usually led by well-intentioned environmental groups, ecological restoration is applied with religious zeal (and virtually no design) to every and any waste site, with no regard for history, context, or culture, let alone emergent and new ecologies that might be worth considering. Whether horticulturally or ecologically, to greenwash indiscriminately and uncritically every empty lot or pocket of unused space is paradoxically a form of what Meyer calls "erasure and amnesia." In doing so, we engage in what amounts to little more than a revisionist fantasy. Any truly meaningful reinterpretation and reinvention of a site's

history must take its context and future into account; it must be woven thoughtfully into the contemporary urban fabric, and animated by its inhabitants.

Why the obsession with greening versus reinvention of these spaces? The contemporary metropolis is vibrant with change; it is characterized by diversity, complexity, new ideas, and dynamism. Perhaps, in the face of such change, we crave the illusion of permanence. Disturbed by the loss of "natural" landscapes to cavalier urbanism, we seek, by enlisting "nature," to remake the pristine pre-colonial landscape—a dream akin to recapturing virginity. Ironically, we try to do so most desperately in our waste spaces, where "nature" in any real sense is long gone—erased, and now replaced, by humankind.

Perhaps, instead of blindly applying a one-size-fits-all nature Band-Aid—simple, mindless regreening—we ought to challenge, contest, and even celebrate previously wasted space. Increasingly, there is hope: contemporary landscape architecture has been revitalized in recent years, and we have seen a new breed of master plans emerge. This trend is particularly evident in postindustrial parks like Duisburg Nord, Germany, and more recently in Fresh Kills in Staten Island, New York, and Downsview Park and Lake Ontario Park in Toronto, all of which feature complex, layered, contextual, and brave approaches to waste space. These projects are reinterpreting and remaking what was once waste space as meaningful, productive place. Through designs like these, which implement a thoughtful and respectful weaving of culture and nature with history and context, there is rich potential to create resonant, useful spaces that speak to the diversity of the contemporary city. The results exude creative tension—between past and present timelines, native and exotic species, cultural and ecological complexity, and most starkly, in their

expressions of beauty. In reconsidering our junkscapes, we ought to resist the impulse to sweep away the past: when we eradicate such places' often rich history we also throw away our own, triumphs and folly alike. Surely, in the postindustrial, postmodern metropolis, there is space to repent, and place to reinvent.

Georgia Daskalakis and
Omar Perez (2001)
Projecting Detroit
Stalking Detroit
Georgia Daskalakis, Charles Waldheim,
and Jason Young, eds.
Barcelona: ACTAR

Nigel Dunnett and
Noël Kingsbury (2005)
Planting Green Roofs and Living Walls
Portland: Timber Press

Deborah Gans and
Claire Weisz, eds. (2004)
Extreme Sites:
The "Greening" of Brownfield
New York: Academy Press

Dolores Hayden (2004)
A Field Guide to Sprawl
New York: W. W. Norton

Niall Kirkwood, ed. (2001)
Manufactured Sites: Rethinking
the Post-Industrial Landscape
New York: Spon Press

James Howard Kunstler (1993)
The Geography of Nowhere:
The Rise and Decline of America's
Man-Made Landscape
New York: Touchstone

Elizabeth K. Meyer (forthcoming)
The Park, the Citizen, and Risk Society
Large Parks
Julia Czerniak, ed.
Princeton: Princeton Architectural Press

Ignasi de Solà-Morales Rubió (1995)
Terrain Vague
Anyplace
Cynthia C. Davidson, ed.
Cambridge: MIT Press

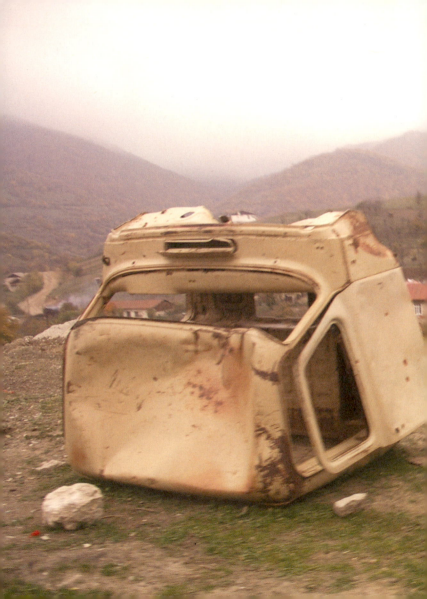

IN | OUT

Braden King,
Gariné Torossian,
and Tigran Xmalian
sort junk in
post-Soviet Armenia.

Photographs of Yerevan and the Nagorno Karabakh Republic throughout by Braden King

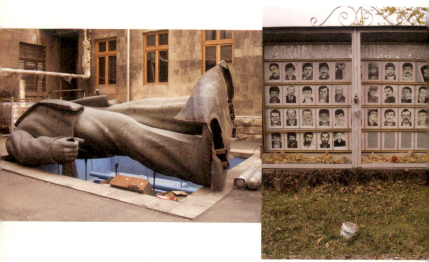

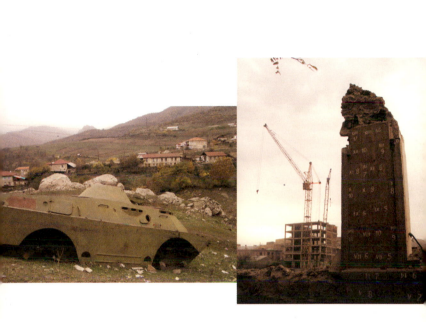

Երեւանը նորից դադարեց քաղաք լինել: Դառնալով Հայաստանի հանրապետության կենտրոն 1918 թվականին՝ այն իրական մայրաքաղաքի տեսք ստացավ միայն վաթսունականներին, երբ պատերազմից հետո ծնված սերունդն ու հայրենադարձները համալրեցին քաղաքի բնակչությունը: Սակայն քսաներորդ դարի վերջում Խորհրդային Միությունից անկախացած Հայաստանը ստիպված էր դիմակայել տնտեսական դժվարություններին, քաղաքական քաոսին եւ կտրուկ սոցիալական փոփոխություններին:

Հայաստանը դարձավ գյուղացիների երկիր, իսկ Երեւանը՝ հիմնականում գյուղացիներով բնակեցված քաղաք–ուրվական: Մնացած քաղաքի բնակչությունն ու նորեկ գյուղացիները բոլորովին տարբեր վերաբերմունք ունեն հատկապես աղբի նկատմամբ: Նրանց համար, ով ապրել է Երեւանում մեկ սերնդից ավելի, այն ամենն, ինչ գտնվում է քաղաքի պատերից ներս, պատկանում է իրենց ընդհանուր տուն հանդիսացող քաղաքին: Նրանք չեն զգում աղբը պատուհանից դուրս, քանի որ ընկալում են փողոցն իբրեւ սեփական տան շարունակություն: Մինչդեռ գյուղացուն նման վերաբերմունքը հանրային տարածքին բնորոշ չէ, նրա համար փողոցը ներկայացնում է դրսի վայրենությունն ու օտարությունն, եւ ոչ թե համայնքը: Հետեւաբար, նա առանց երկմտելու թքում ու կեղտոտում է փողոցում, կամ էլ աղբ է զգում տնից դուրս: Դրսի աշխարհն իր թշնամին է, եւ նա ատելությամբ է պատասխանում դրա կոշտությանը:

Ահա այսպես է աղբ առաջանում Երեւանում:

—Տիգրան Խզմալյան

Yerevan has ceased to exist as the city it once was. Although it formally became Armenia's capital in 1918, it only achieved the look of a capital city in the 1960s, after the baby boom and repatriations had swelled the urban population. But Armenia's independence from the Soviet Union in the late twentieth century brought economic hardship, political chaos, and rapid social change. A million Armenians, almost all of them city dwellers, left the country. Armenia is now primarily a land of villages. Yerevan is the ghost of a city, occupied by villagers.

The remaining city folk and the villagers have different attitudes toward garbage. To those who have lived in Yerevan for a generation or more, everything within the boundaries of the city walls is their common home, and they respect it accordingly. You don't throw garbage out your window, because the street is also part of your home. However the villager regards such public space differently: for him the street represents the wilderness, not his community. That's why he doesn't hesitate to spit or vomit in the street, or throw his garbage into it. The outside world is his enemy, and he meets its hostile conditions with like treatment.

This is how I understand what has happened to Yerevan.

—Tigran Xmalian

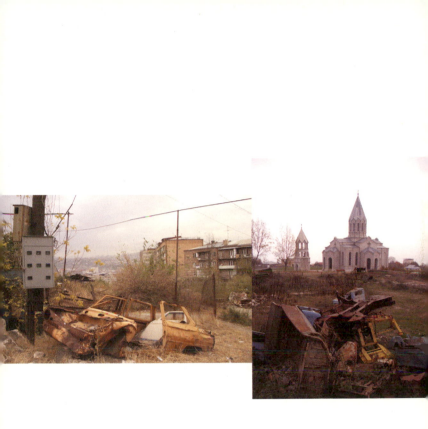

Stills from Gariné Torossian's video *Stone, Time, Touch*

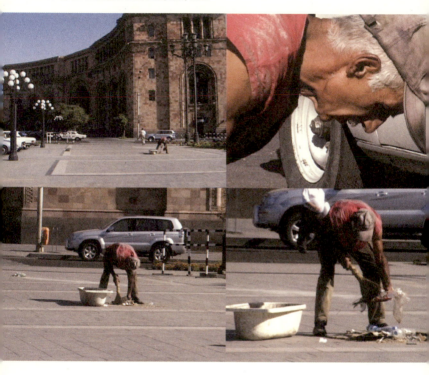

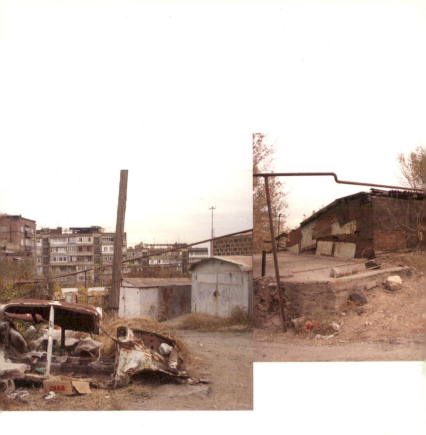

THE HARBINGERS

In Nyla Matuk's fiction the year is 2029 and something is awry in China's zero-waste cities. Drawings by Derek Sullivan.

listen to the laughing thrushes,
striated, white throated, orange headed, all
the plain-backed, blackened, chestnut, cocoa,
summoning oblivions, raining disasters
—Dionne Brand

I arrived at the Butterfly Wing Hotel late at night, in a busy area of the newly developing industrial city of Liaoning. The building shell had once housed a silk plant and in its new incarnation floodlights illuminated a set of diaphanous screens enveloping the building. The cube of the hotel looked small and animated under the soft commotion of the light around it.

Entering the foyer, I was struck by the sight of a Haida totem pole at least twenty-five feet high and carved with ravens, crushed against each other cheek by jowl. A butterfly emanated from one raven's beak like an otherworldly tongue.

My room was airy and spacious, nicely appointed in Edwardian style: faux ebony vanity table, four-poster bed, and the like. As I unpacked, I started asking myself again if my work was worth all this trouble. In any case, there was no going back now. I was here to do the research that would help me write the last chapter in a book, *New Environmentalism in China*—a project now going on its third year. Some time this week I would need to contact de Winter, my editor in London. He had, most recently, moved beyond his impatient, repetitive questions about when my chapter manuscript would reach his desk and had sallied, not unnoticed, into a hostile radio silence. Is it ever otherwise with editors?

The piece I had promised him on Liaoning was weighing on my mind. I had taken the requisite tours, some months ago, of parks and gardens, new buildings, and so-called "cradle to cradle" industrial infrastructure. But instead of packaging some sophisticated prose on all this, I was becoming obsessed by what people had said about this part of the country—that crows, ravens and other corvids seem to have disappeared. In fact they had multiplied considerably in number when the city—and others like it—had begun to take shape and as the populations grew. The overbreeding didn't seem unusual—they're

survivors. Then, suddenly, they were gone. Though my brief was enlightened design, not ornithological mysteries, I kept thinking about this disappearance. It has only been noticed in these new cities, cities where nothing is wasted, where everything works inside a closed loop of manufacture, agriculture, and industry. Nothing toxic, surplus, or disposable is ever produced.

Those dangers and potentialities have been banished.

The present disappearance was possibly the result of an absence of garbage, but to be honest, I had no definitive answer. These birds always adapt to new human conditions; if agricultural practices cleared the forests, the crows revolutionized themselves with them, accepted new crops as food, and changed their migration patterns in accordance. Corvids—that is, crows, ravens, jackdaws, rooks, and other birds of the species—eat everything that presents itself in their environment: fleas off the backs of pigs, corn in the fields, the livers of recently hatched garden snakes. The more carnivorous amongst them—carrion crows, magpies, and ravens—scavenged battlefields of dead bodies for centuries. And they are clever at making conveniences for themselves. Some Norwegian corvids have been observed picking walnuts from trees, dropping them into the middle of a busy road, waiting for the cars to crack the shells for them.

I had read that if they sense environmental disaster, they over-breed—more nestlings mean a better chance of species survival. I drifted off with this on my mind.

I awake the next morning to a room filled with golden sunlight spilling onto a reproduction of an Edo screen of crows. I order a rickshaw to take me through Liaoning's narrow greenways. The pedestrians have been separated from bicycles, cars, and rickshaws so that getting through the city on these new roadways is smooth and fast. While Liaoning is only twenty-eight square kilometres in area its population is densely concentrated. They've built new housing for over 4 million people in the last twelve years, and it wouldn't do to have traffic jams. The Party orchestrated these moves, planned them as much as the ancient city of Angkor Wat was planned. An American architect is largely responsible for the urban designs, having hatched what he calls a life-cycle development process; everything is a biological nutrient that goes back into the earth as a nutrient of "value"—waste is turned into fuel. There is also what they call a "technical" nutrient, which is in a continual cycle of use for new or repeated product manufacture. The cradle of one product, or system, can only metamorphose into a cradle for another one, never a landfill grave of the kind we saw so much of in the twentieth century.

Traveling through Liaoning, I can see the greenway ahead of us like the brightly unfurling flag of some utopia of yore, opening views to the urban fabric as it slides along the elevated landscape—as gentle as heather on English moors—and dips down into more populated areas. The repatriation of people by the Chinese government was forceful and brutal at times. They were ousted from the countryside and re-housed in the "new socialist countryside" or in a city like this one. People seem stoic as ever, more so as they go about the service industry jobs—the waitress at the Lucky Nest Restaurant across from my hotel, the drivers, the hotel porters. It isn't clear if they are used to the crowded new city by now, or if they are still trying to adjust to this drastic upheaval of their lives.

Finally the road narrows toward the built-up density of the city center. From a distance, it looks like a Victorian curio populated with delicate rosewood figurines. All the brick buildings had been destroyed in the countryside, and the populace now lives in seven-storey apartments or more commonly in three-storey live/work buildings clad in a symphony of browns. These have shops on the ground floor, and living quarters on the second. I can see that some buildings have rice paddies on the roofs. All the grey water is pumped upward to feed them, and the black water goes into giant bio-digesters. The wastewater is also piped to the fields to be used as part of a fertilizer system.

The buildings and transportation corridors are astonishing in their vast diversity, still surprising and different enough from Europe and North America for me to think it's all science fiction. This kind of adaptation, on such a massive scale, seems so orchestrated that it would be doomed to failure, but all parts of the machinery, the thinking and closing of the loop, appear functional. At least from the surface, from the point of view of those who have come here from abroad to do business, which is the Party's main concern now that they've appeased the environmentalists with their new urban developments.

I disembark in the town square to take a little walking tour that I had planned for most of the afternoon. In the center of the square, surrounded by concrete benches, a thin, flat-screen broadcast monitor

squawks a Party-produced dramatization of an apparently smooth-running and auspicious occasion: a family of six is being removed from their farm to a city that looks very much like Liaoning. I am standing in a crowd of about twenty city-dwellers. They watch attentively, wearing cynical half-smiles and frowns on their faces. Then a man speaks up—actually, he begins to yell at the screen in Cantonese and finishes by throwing an apple core at it. Then an advertisement for apparently healthy cigarettes begins, and the sound of the jingle, like all television commercials, rises appreciably. The thirty-foot console holding the screen is encased in a sort of faux-plaster, ornately embossed with a pattern of ravens flying in one direction on one side, and the opposite direction on the other. As he rolls up the sleeves of his coveralls, I glimpse a tattoo of a raven on the forearm of the man who threw the apple core. Are they all subtly acknowledging this disappearance? It is starting to seem like a cult to me. Well, it isn't the first time I'd seen people angrily staring at the relocation propaganda broadcasts. They were removed from their homes at gunpoint, apparently.

In these cities, a kind of alchemical process transforms base matter into useful, if not auriferous, commodities. An outdated computer's parts are returned to the manufacturer, who coaxes their useful cadmium souls from the detritus of their zinc and steel bodies and recalls them to life by fitting them into newer models. Some are redeemed in their entirety, such as computer monitors, and are sold to television manufacturers. The manufacturers take advantage of the advanced graphics quality, which they apply to the latest television screens. They are not just for the town squares here; you see them now embedded in the West in bathroom stalls, closets, napping huts at airports, public restrooms in European cities, and as all-pornography broadcasting devices affixed to the ceilings of the bedrooms of the American middle class and the sex shops of Amsterdam and Berlin.

I cross a bicycle path and arrive at what looks like a large greenhouse at the headwater of a network of rivers. This is a distribution center for rooftop garden plantings, shrubs and seeds largely responsible for the insulation of a building when the businesses in it aren't using the roof to cultivate crops. It seems odd that the rooftops here are not encouraging birds at all. When I lived in Berlin, I would see many crows and jackdaws swooping down in the Potsdamer Platz on crisply lit winter evenings, seeking any warmth that might radiate from the glass of the skyscrapers. Granted, they are so adaptable that it may be only a matter of time until they figure out that the crops here are also plentiful, and that the vegetation they know in fields and landscapes can now also be found, and harvested, from urban rooftops. And yet. It's been twenty years of new development, and the only corvids around are drawings, tattoos, or symbols.

On a whim I dial de Winter in Manchester Square expecting to leave a message, but he answers on the first ring. I want to let him know about how angry the people were about the displacement. Casually, I mention the corvid disappearance in case he is open to my adding this to the chapter.

"Well, that's a hell of a lot less to worry about than human rights abuses. At least the relocation measures, even if they are harsh, are best in the long run. Imagine that number of people trying to get on like the rest of world, with SUVs and fast-food outlets." This is his usual mélange of analysis and jingoism.

I end the call by promising him the completed manuscript soon, but we both know he's not convinced.

Organic waste, those tidbits of refuse and human detritus so enthusiastically pecked up by corvids, is now entirely re-entered into the nutrient stream for agriculture, with the help of giant biodigesters. Packaging materials are biodegradable, and go to mingle and dissolve in the biodigesters along with the coffee grounds and bacon slices they once enveloped.

The biodigester company—the place where these giant eating machines are being created by the dozens for most of China—announces itself across the street with the help of a giant neon sign of massive ideograms, looking like a carnival attraction in nighttime Tokyo. On closer inspection, it isn't neon but something very similar—maybe some clean nutrient in gaseous form that behaves like neon—I'll have to research that. I look at my list of industry sector

buildings and discover that it is called, interestingly enough, the Raven Biodigester Headquarters. The ideograms must be spelling out the words in Cantonese. Maybe the birds are only an idea here now, an idea that has germinated one of the most important technologies for the new manufacturing and economy. This reminds me how hard the people in these cities—indeed, everywhere—had to plan and design and work, just to take a place in a world where other species fulfilled their part merely by doing what their natures told them. Taken a step further, it might be imagined that the corvids' urban adaptability is an example to the architects of what they can do in the new cities; to imitate corvids is to use reinvention, adjustment, and ingenuity to feed the loop.

I make my way to a shoe factory. The shoe soles, the factory foreman explains, could decompose harmlessly into biological nutrients. As with shampoo bottles and ice cream cartons, they will end up going through a wetland and eventually into a lake where their components support the balancing act of the ecosystem.

This kind of malleable, practical building and manufacturing ethic is a far cry from the futuristic, fascistic machines of industry offered up by Marinetti in the 1920s; or the rise of the enterprising corporate city so heavily symbolized in the perfect shapes of a Mies tower. Nor is it in any way reminiscent of the surreal, unctuous dreamscapes that rise out of the concrete of Oscar Niemeyer's Brasilia. In fact, this stands in stark opposition to the kaleidoscope of twentieth-century decadence—from the poetic decadence of urban design and architecture, so rooted in artistic movements early on in that century, to the later prosaic decadence of acquisition, status, and what was called (transparently, shamelessly) consumerism. The totemic and real excesses of the Trump Tower, the mega-mall, the hypermarket.

As evening falls I make my way back to the central commuter hub. I eat an omelet in a smoky, forlorn cafeteria near the station. The night arrives heavily; dark clouds scud overhead while I, like the subject of an Edward Hopper painting, contemplate the glum meal on the plate in front of me. It is Communist kitsch to sit here, playing the part of an outsider—a bohemian—especially as a pair of menacing-looking security men, alighting from a train, parade their German shepherds, whose snouts are muzzled with miniature chrome cages.

I board a train that follows the green rail corridor back to the vicinity of the Butterfly Wing Hotel. We travel beneath a tangled, ophidian web of elevated roads that will soon be dismantled. Its materials are old and toxic, and I wonder where they could be shipped if nobody cares to reuse them here. Like the darkened winter walkways in Tivoli Gardens, Copenhagen, these roads look mirth-less, and seem to hope for busier, better days. They rust and sigh but maintain an imposing, abject presence above the new commuter rail system that runs along the soft terrain beneath.

The Lucky Nest's red neon glow bounces onto the hotel's two cubistic volumes and spills onto the sidewalk of the narrow street as I approach. As soon as I take up my usual seat by the window, the waitress brings me a cup of thick tea. I notice she has a tattoo of a raven similar to the one I'd seen on the man in the town square. She gestures to the tea, now in front of me.

"This reminds us of poison," she says in a low voice, "they poison and kill black birds like this."

I assume "they" refers to the Party.

"But why?"

"They destroy everything to make their new city. They want a perfect city, no extra food, no extra animals. Better than America. Maybe one day they will say there are too many people!"

From the restaurant window we both watch the hotel guests and porters coming and going. A van drives up and parks to the side of the main door in the hotel alleyway. Two men emerge, one with a large white bag. They're wearing coveralls and large stiff gloves. They head to an area close to the carp pond that runs underneath the little bridge connecting the hotel's two buildings. Bending down among the reeds, they both start filling the bag with whatever is polluting the edge of the pond.

"See?" the waitress says, leaning over the table and rubbernecking at the window, "they put poison everywhere. They pick up birds at night, always at night."

The men throw the bag into the back of the van and drive away.

I finish my coffee and walk over to look around. A soil sample might be worth taking. Then I notice a raven they left behind. Its body has stiffened but its eyes shine feebly under the hotel floodlights, like the eyes of a Tasmanian devil I had seen once in a barely lit pavilion of nocturnal animals at a zoo. There is something in both sets of eyes that tells me they have seen the fire and ice at the end of the world. I take the bird up to my room. Wrapping it carefully, I place it in a box to take home.

CHINA RECYCLING #9
Circuit Boards, Guiyu, Guangdong Province, 2004 (detail)

RECYCLING

Edward Burtynsky photographs
recycling facilities in China and Ontario.

DENSIFIED SCRAP METAL #3A
Hamilton, Ontario, 1997

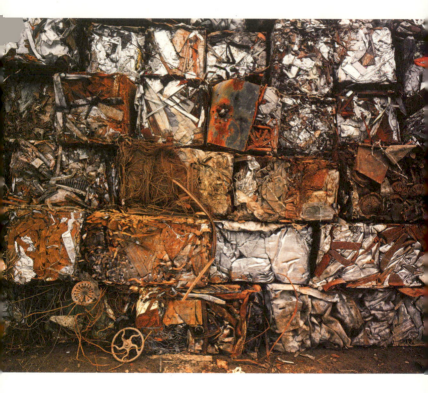

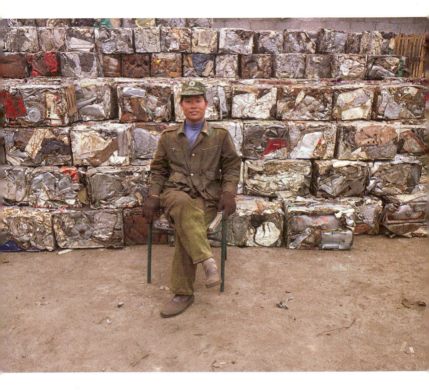

SCRAP AUTO ENGINES #11
Hamilton, Ontario, 1997

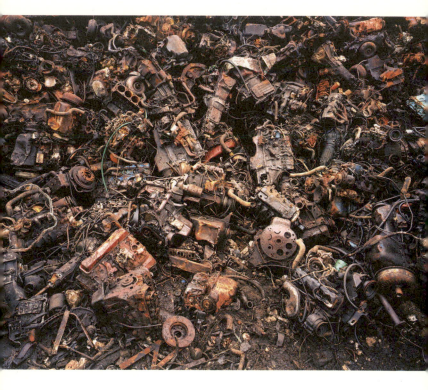

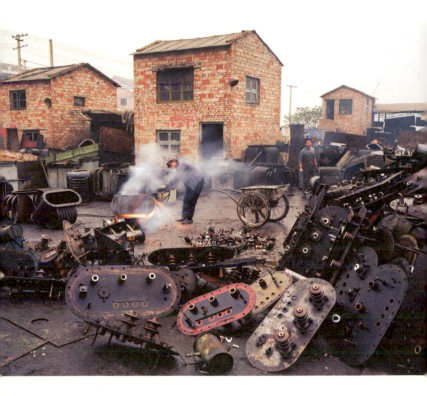

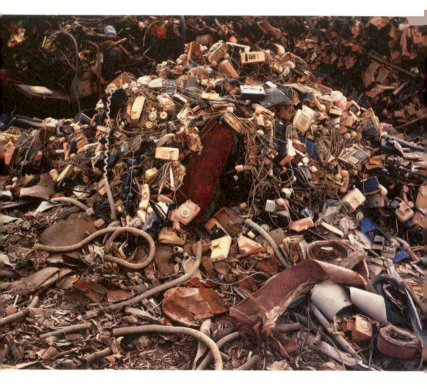

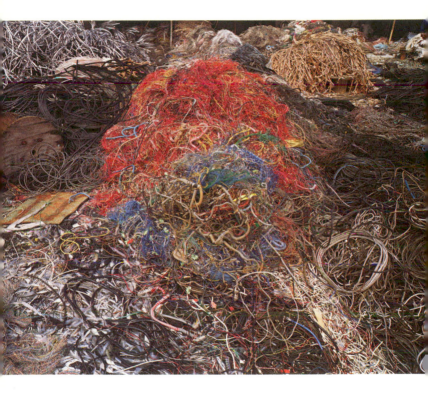

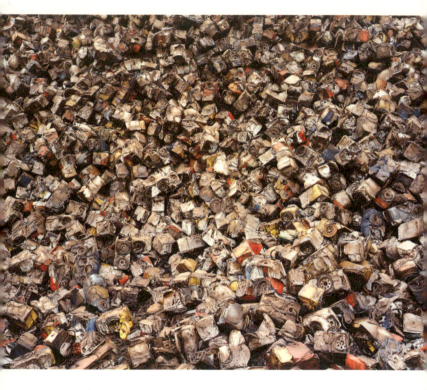

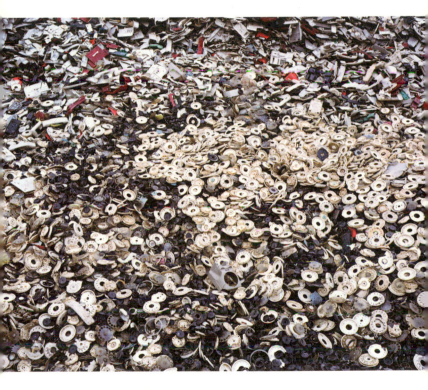

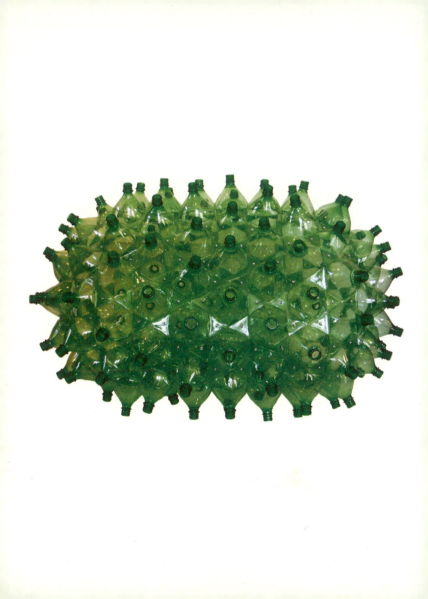

MESSAGE IN A BOTTLE

Mass-scale trash is the outcome of our economic system, argues Heather Rogers.

The words "Look it!" shout from the page above the coyly tilted head of a well-coifed young housewife. Her amphetamine-bright eyes convey her excitement. In each hand she clutches a bottle of beer; her right elbow is retracted and her taut left arm is outstretched, hoisting the brew skyward in a pose a cheerleader might strike. This perky beer pusher is the centerpiece of a 1947 double-page advertisement for one of the earliest no-deposit, no-return glass bottles marketed in the United States, the Duraglas, manufactured by Owens-Illinois Glass Company. Across the top of the ad, a banner proclaims, "Beer and Ale in glass bottles you don't take back!" The copy goes on to explain, with detailed illustrations not unlike a set of instructions, that with the new Duraglas the purchaser no longer has to leave a deposit at the grocery store. Instead she can toss the once-used container in the rubbish bin, because "After you've enjoyed your favorite brew, the ONE-WAY glass bottle has served its time." And thanks to this new, liberating system there's "No more bother of lugging empties back for refunds!"

Perhaps surprisingly, it was only about fifty years ago that disposable, single-use cans and bottles were introduced on a mass scale in the US. Today disposables dominate, but before they took over the market, sturdy refillable glass bottles were ubiquitous, containing everything from beer to soda and milk. It was only during the 1970s, and in some places the 1980s, that beverage makers phased out the reusable bottle. The end of the refillable triggered an onslaught of packaging production and increased consumption. It also created unprecedented levels, and whole new types, of garbage.

By the mid-1970s, packaging had already become the single largest category of municipal solid waste in the United States, and today once-used wrappers, boxes, cans, and bottles take up more than a third of the country's landfill space (Fenner and Gorin 2; US

EPA 2003, 7). Most of those vessels are stamped with the tri-arrow recycling symbol, but they end up in the trash anyway. According to recent statistics, just 25 percent of all plastic soda bottles are recycled; only a third of all glass vessels are melted down for reuse; and a mere half of all aluminum cans are reprocessed (US EPA, *Basic Facts*). Over the last thirty years, since single-use beverage containers have ruled the market, the amount of rubbish generated in the US has doubled (US EPA 2003, 3–4).

Finding ecologically sound solutions to the devastation wrought by this reverse cornucopia is imperative. In doing so, it's useful to look back at how we got into this predicament. Most of us in the West like to believe that today's high-octane rubbish output is inevitable, the result of something intrinsic to human nature. People want what they want when they want it. The consumer demands convenience, and what can manufacturers do but supply it? In reality, however, the shift to more trash-heavy ways is deeply connected to the free market economy's ongoing need to intensify and expand consumption. In order to maintain economic health, manufacturers have to keep people buying. Indeed, an economy that relies on constant growth requires wasting. The deliberate jettisoning of the refillable glass bottle in the US illustrates the underlying mechanisms that contribute to the garbage-intensive system we struggle with today. Understanding the structural reasons for this surge in waste can help us plan a future with less garbage. A change of direction is urgently needed, and not only because our rising swells of rubbish are environmentally unsustainable at home. As neoliberal free market development spreads across the globe, so too does its torrent of trash.

NO-DEPOSIT, NO-RETURN

Although the first single-use can and bottle were introduced in the 1930s, producers at first failed to fully grasp the profit potential of throwaways. Additionally, restrictions on metal and glass kept mass production of disposables at bay during World War II. All that changed in the years after the war. The search for ever-expanding markets was heating up, and by the late 1950s, the drink and container industries, like their counterparts in most other fields, had jumped on the disposables gravy train. The benefits to manufacturers who used discardable packaging were numerous: it generated higher consumption rates, created new marketing possibilities, and allowed for the consolidation of the beverage industry. With these incentives, the switch to disposables came on quickly. The use of old-fashioned refillables for soda dropped from 98 percent in 1958 to just 39 percent in 1972; and by that same year 82 percent of beer containers were also one-way bottles (Fenner and Gorin 4).

The profits were significant: every time a drink was consumed, the empty package was thrown away. For every reusable bottle, anywhere from twenty to forty single-use containers were bought and permanently trashed. And since shoppers were willing to pay for the added price of the bottle along with the contents, manufacturers could introduce a new form of almost hidden consumption. Packaging is barely perceptible as a commodity; its limited use-life and its predetermined fate as waste have become acceptable on a cultural level. Yet it contains natural resources and human labor—and produces profit–like any other manufactured good. As the industry magazine *Modern Packaging* noted in 1961, "There appears to be a gigantic field for growth in non-returnables" (289).

The advantages for container makers were obvious—more units discarded meant more new sales. But disposables also presented marketing benefits. By packaging beer and soda in novel, eye-catching one-way vessels, beverage companies could pull consumers' attention away from their rivals' products on crammed self-service supermarket shelves. Known in the industry as "nonprice product promotion," flashy packaging could be used instead of lower prices to get an edge on the competition (Fraundorf 810-16). The new trashable wrappers could boost sales while keeping prices the same or even raising them.

Most significantly, disposable packaging played a central role in the dramatic restructuring of the beverage industry in the years following WWII. By replacing refillables with throwaway bottles and cans, the major drink makers were able to more easily consolidate the beer and soda industries, taking over a much greater market share. At the time, the big beverage makers were pushing for increasingly centralized, streamlined production and distribution As a local Pennsylvania bottler, Peter Chokola, explained in 1974, the refillables system imposed "a natural limitation on the market area served by a bottling plant." Delivery trucks were tethered to a restricted geographical area; they could not venture long distances because they had to return to the plant with the empties. According to Chokola, "Thousands of small and medium hometown bottling plants were therefore necessary to market beverages." Disposables allowed large firms like Coca-Cola and Pepsi to bypass smaller producers and, as Chokola noted, "provided the medium through which monopolization of the soft drink industry could be achieved" (Lerza 5; Commoner 106).

Thousands of local and regional bottlers began to fold. Of the 5,200 soft drink makers in the US in 1947, only 1,600 were still in

business by 1970. Consolidation in the beer industry was even more extreme. In 1950 the US had more than 400 breweries, but by 1974 there were only 64. A study conducted for the US Environmental Protection Agency (EPA) said that monopolization in the brewing industry was "encouraged and permitted by the introduction of non-returnable containers" (Lezra 5).

And while the national brewers were expanding, wiping out their less capitalized competitors, the flourishing new geography of suburbia was changing consumption patterns. Individually bottled beers in six-packs designed for take-home consumption replaced old-fashioned keg distribution to taverns (Wrap-Up for Glass, 156–59, 287, 289). The grocery business was also changing, and the big supermarket chains preferred disposables, because they eliminated the added labor time and the expensive storage space that reusables required. The resulting surge in wasting was staggering. Between 1959 and 1972, while the quantity of beer and soft drinks consumed increased 33 percent per capita, the number of containers consumed skyrocketed by 221 percent (Fenner and Gorin 3). And with minimal restrictions on production and disposal, all those barely used bottles and cans were going straight to the garbage pile; by 1976 packaging, by weight, had become the single largest category of municipal solid waste (Fenner and Gorin 2; Blumberg and Gottlieb 13).

In switching to disposables, beverage makers and packagers furthered the Fordist mass assembly-line practice of "externalizing" costs—passing them on to the consumer, to municipal refuse collection, and to the environment. An Antitrust Bulletin article from 1975 called this externalization "private-to-social cost shifting" (Fraundorf 813). The conversion to throwaways unfailingly pushed profits higher.

FROM 1959 TO 1972
INCREASE PER CAPITA

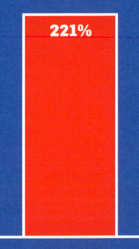

221%

33%

in soft drinks and
beer consumed

in containers
consumed

Source: *Local Beverage Container Laws: A Legal and Tacticl Analysis,*
Thomas W. Fenner and Randee J. Gorin.

Not surprisingly, packaging and drink makers worked diligently throughout the 1970s on the political front to undermine attempts to introduce new legal controls on wasting. The range of legislation debated across the country at the time included outright prohibitions on single-use packaging, public oversight of packaging materials, mandatory deposits on disposable containers, and the implementation of municipal recycling. Manufacturers doggedly opposed all these initiatives with lobbying, legal challenges, and media campaigns designed to sway public opinion. And it worked. As of 1976, every US state legislature and numerous town, city, and county councils—more than 1,200 in all—tried to impose some form of restrictive packaging law. But almost all failed: at the end of the decade only Maine, Michigan, Iowa, South Dakota, Connecticut, Delaware, Oregon, and Vermont had adopted any beverage container measures. Crucially, these laws applied only to beer and soda bottles; powerful industry pressure won exemptions for liquor, wine, and juice packaging (Fenner and Gorin 13). By the 1980s, not only had hundreds of proposed container restrictions gone down to defeat, the beverage industry had also purged most reusable packaging from production lines. The average consumer, regardless of what she really wanted, was left with the freedom of a narrowing choice of disposable, one-way containers, creating ever more massive mountains of garbage.

MANAGING WASTE PERCEPTIONS

How could this have happened when the overwhelming majority of consumers, according to a poll conducted in the US in the 1970s, preferred returnable systems? The packaging and beverage industries' success in shaping public opinion about waste was crucial to their success. Two key components of this perception management

project were the ascendance of the anti-litter group Keep America Beautiful in the 1950s, and the rise of the mainstream recycling movement in the 1980s. Both efforts are rooted in the now common practice of corporate "greenwashing," which strives to convince consumers that environmental problems are being tackled by industry, so that individuals can carry on buying, and governments do not need to intervene. The underlying goal of both campaigns was to keep commodities flowing by protecting production from regulation.

In many ways industry's elaborate green offensive began with the earliest effort to restrict disposables in 1953. A measure passed by the Vermont state legislature—coming not from nascent environmentalists, but disgruntled dairy farmers—banned the sale of throwaway bottles throughout the state. According to a newspaper report: "Farmers, who comprise nearly one-third of the House membership, say that bottles are sometimes thrown into hay mows and that there is need to prevent loss of cows from swallowing them in fodder" (Fenton). Their livelihoods on the line, the husbandmen politicians ratified the law to protect their animals from death by ingestion of stray glass containers. But this action sent shock waves through the burgeoning disposables industry. Within a few short months packaging makers joined forces to concoct a lavishly funded nonprofit organization called Keep America Beautiful (KAB). This group was the first of many great greenwashing corporate fronts to come.

KAB's founders were the powerful American Can Company and Owens-Illinois Glass Company (maker of Duraglas), inventors of the single-use disposable can and bottle, respectively. They linked up with more than twenty other industry heavies, including Coca-Cola, the Dixie Cup Company, Richfield Oil Corporation (later Atlantic Richfield), and the National Association of Manufacturers. Still a major player today, KAB came out swinging, urgently funneling vast

THE DECLINE OF REFILLABLE BEVERAGE BOTTLES IN THE US

SOFT DRINKS SOLD IN REFILLABLE BOTTLES

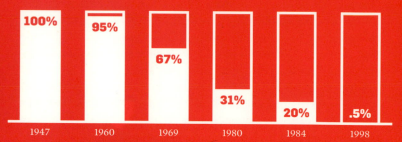

1947	1960	1969	1980	1984	1998
100%	95%	67%	31%	20%	.5%

BEER SOLD IN REFILLABLE BOTTLES

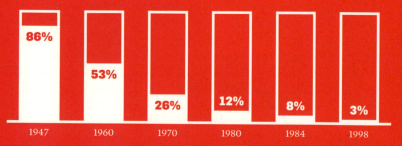

1947	1960	1970	1980	1984	1998
86%	53%	26%	12%	8%	3%

resources into a nationwide, media-savvy campaign to convince the public that the rising swells of trash were the result of individual bad habits, not unregulated industry.

The centerpiece of the organization's strategy was its great cultural invention: litter. This category of debris existed before, but KAB masterfully transformed its political and cultural meaning to shift the terms of the garbage debate, diverting any stirrings of environmental awareness away from industry's massive and supertoxic destruction of the natural world. Ecological disaster was reduced to the "eyesore" of litter, and the real villain was the notorious "litterbug" who failed to put his discards in the proper place. The key tactic of blaming individuals—as one American Can executive insisted, "Packages don't litter, people do"—obfuscated the real causes of mounting waste (Blumberg and Gottlieb 19). KAB downplayed industry's role in despoiling the earth, while relentlessly hammering home the message of each person's responsibility for the destruction of nature, one wrapper at a time. On the second Earth Day in 1971, KAB launched its now famous television ad campaign featuring the longtime Hollywood actor, Iron Eyes Cody (who was posthumously outed as being of Italian, not Native American, ancestry). A buckskin-clad Cody stood in litter-strewn landscapes shedding a single tear as the voice-over announced: "People start pollution, people can stop it."

KAB was a pioneer in sowing confusion about the environmental impacts of mass production and consumption. The group understood that if the public believed industry was responsibly handling natural resources and that production under a free market system was sustainable, then they must accept that they were to blame when waste got out of control. With this Orwellian flipping of the script, laws would not be enacted, governments would not intervene, and

production would continue on industry's terms. This sophisticated manueuver is a classic example of what the father of PR, Edward Bernays, called "the engineering of consent" (Ewen 376). KAB understood that people's anger about waste could be turned to industry's advantage. In broad terms, this dynamic is explained by philosopher Raymond Geuss: "Although reactions of avoidance and disgust seem to be rooted in basic facts of human biology and exist in all human societies, the particular form they take is culturally shaped and is acquired only through a long process of training" (Geuss 18).

The next wave of garbage-related greenwashing accompanied the rise of mandatory recycling programs in the late 1980s and early 1990s. The popularization of recycling was the outcome of a major landfill crisis combined with the burgeoning environmental justice movement, which was made up of neighborhood groups that pressured elected officials for alternatives to burning and burying wastes. In the mid-1980s the EPA implemented a provision of a 1976 US law, the Resource Conservation and Recovery Act, which required minimum safety standards for land disposal sites. Aging facilities were required to clean up or shut down. At that time, 90 percent of US wastes were disposed of on land and an estimated 94 percent of those sites were not up to standards. As a result landfills were shuttered by the hundreds, and two-thirds of them closed during the 1980s (Center for Investigative Reporting and Bill Moyers 7; Halleman). At the same time, garbage output was exploding; between 1960 and 1980 the amount of solid waste in the US quadrupled (Seldman 2352). Municipalities had to find other solutions, and find them fast.

With industry snuffing out measures like mandatory deposit laws and source reduction (requiring manufacturers to make less wasteful products), recycling underwent a renaissance. Across the country,

schoolchildren put down their glue and macaroni to learn the virtues of "closing the recycling loop," and suburban housewives made room in their kitchens for extra bins to separate paper from cans and bottles as municipalities began implementing recycling programs.

In the 1980s curbside recycling systems were adopted—many of them mandatory—in Connecticut, New Jersey, New York, Rhode Island, and Maryland, while dozens of American cities and counties passed their own measures (Blumberg and Gotlieb 208). By the late 1980s, there were more than 5,000 municipal recycling programs in the United States, up from just 10 in 1975 (Seldman 2356). And in 1993, almost a quarter-century after the first Earth Day, the EPA reported that domestic recycling had tripled by weight, from 7 percent to almost 22 percent (Strasser 285). As more cities adopted voluntary and mandatory recycling measures, growing numbers of Americans welcomed recycling into their daily routines.

All this eco-friendly activity put business and manufacturers on the defensive. With landfill space shrinking, new incinerators ruled out, water dumping long ago outlawed, and the public becoming more environmentally aware by the hour, the solutions to the garbage disposal problem were narrowing. Looking forward, manufacturers must have perceived their range of options as truly horrifying: bans on certain materials and industrial processes; production controls; minimum standards for product durability; and higher prices for resource extraction.

In this climate, manufacturers realized recycling was the lesser evil. Remanufacturing single-use materials into new containers and packages would not impinge on consumption levels and would have the least impact on established manufacturing processes. That meant producers could keep making and selling disposable commodities just as they had been doing for decades. As American Can executive

William May put it a few years earlier when discussing the potential garbage tidal wave from so much disposable packaging: "We must comprehend, as a nation, that the solutions also lie, to a very large degree, in technology....We oppose any reduction in productivity" (Lerza 5). After all, the measure of success in the free market system is constant growth, not genuine environmental health.

As recycling fever spread, more people believed they were helping reverse environmental decline while maintaining high levels of consumption. However, recycling rates in the US by the mid-1990s began a trend of stagnation (and in some places, decline) which continues today (Seldman and Platt 10). In large part this is because recycling does not stem the creation of discards. Instead, this back-end refuse management strategy treats discards only after they've already been made, leaving wasteful mass production and consumption unaltered and even encouraged. People often believe that their trash is now benign because they chuck it into a special color-coded bin or bag. Today it's likely that more Americans recycle than vote—yet greater amounts of rubbish are going to landfills and incinerators than ever before (Sledman and Platt 9).

REUSING THE REFILLABLE

Industry's pro-waste offensive, with all its greenwashing, has contributed to misleading the public about the real toll on the environment from maximum production and consumption. These efforts have also derailed public demands for effective waste reduction programs like the reusable bottle. A more sustainable solution to the flood of trash, refillables are profitably employed today in parts of Western Europe, Latin America, and Canada, often by the same US firms that refuse to use them at home. Stimulating local and

PERCENTAGE OF BEER SOLD IN REFILLABLE BOTTLES AROUND THE WORLD

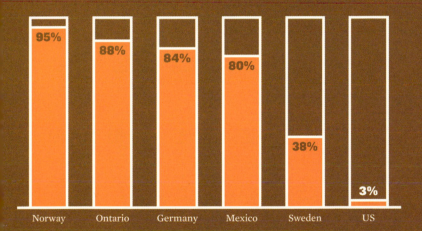

Norway	Ontario	Germany	Mexico	Sweden	US
95%	88%	84%	80%	38%	3%

Source: *Refillables: Saving our Environment*, Brewers of Ontario.

regional economies, refillable bottling plants create more jobs while substantially reducing packaging wastes, saving energy, and cutting resulting pollution.

The way the refillable system works is still familiar to some of us: the thick bottles usually require a deposit and are returned empty to supermarkets and corner stores. From there, beverage makers take them to a washing and refilling facility where they are processed on an assembly line at a pace equal to that in factories using brand-new packaging. Once sealed, the bottles are shipped to retailers and the cycle begins anew. Today refillables are used on average twenty times before getting tossed (Platt and Rowe 27).

Reusables have stuck around in other countries for two reasons: regulatory laws and economics. Several governments have measures that require and promote refillable beverage containers, many of which were put in place in the 1970s to stop single-use containers needlessly clogging disposal sites. Once ubiquitous in the US, refillables still hold the vast majority of bottle markets in Denmark, the Netherlands, Germany, Finland, and in Prince Edward Island in Canada. Beverage makers have also continued using refillables in Latin American countries like Mexico, Brazil, and Argentina because reusable bottles cost markedly less than disposable packaging. For beverage makers, producing drinks that sell at a lower price opens markets of buyers with smaller incomes (Platt and Rowe 1–2).

Coming typically in glass or thick PET plastic, this washable, reusable form of packaging has slashed garbage output by an estimated 380,000 tons annually in Denmark, while Finland has seen an estimated 390,000-ton drop. As of 1998, the annual per capita output of packaging wastes in Finland was half that of other European Union countries, most of which don't mandate the use of refillables. The larger environmental impact of recirculating packaging includes

dramatic reductions in greenhouse gas and carbon dioxide emissions, and reduced consumption of water and energy. The positive effects extend into the creation of jobs, because more workers are needed when companies use refillables than when they use one-way containers. According to one study, if Germany switched entirely to reusable bottles, 27,000 new jobs would be created (Platt and Rowe 1, 33, 5–9, 14–15). And, contrary to the oft-repeated line in countries like the US, people still like bringing back their empties. According to a recent Gallup poll, Finnish consumers preferred buying beer in returnable bottles by a margin of almost 80 percent, while 94 percent favored soda in reusable containers. The majority of Germans—69 percent—want to buy their refreshments in returnable vessels. But it's not just consumers who like less packaging; the Quebec Brewers Association says its members' loyalty to the reusable stems from its unbeatable low cost and high customer participation. If companies are not trying to centralize production and distribution, as giant firms like Coca-Cola have done, then refillables can bring substantial savings (Platt and Rowe 33, 25).

The shift away from reusables to more wasteful forms of packaging was possible because manufacturers deployed the coercive powers of PR to a chilling extent. "The 'engineering of consent' implies the use of all the mechanics of persuasion and communication to bend others, either with their will or against their will, to some prearranged conclusion, whether or not their reaching that conclusion is in the public interest," wrote PR don W. Howard Chase in explaining Edward L. Bernays's core idea (Ewen 397–98). Industrial production and resource extraction have thus far taken shape outside the realm of public participation and are based on increasing profits and expanding markets, not on protecting human and environmental health or reducing our growing mountains of trash.

Industry—and government acting as industry's handmaiden—usually argues that unchecked production is necessary for a healthy economy, good jobs, and a high standard of living. However, according to recent census figures, the US has grown more economically polarized over the last thirty years. Today there is greater income inequality than any time since World War II. This disparity increased throughout the 1990s as the middle class shrank even in the midst of the longest period of economic expansion in fifty years (US Labor Force). Additionally, layoff rates are higher today than they've been since the deep recession of the early 1980s. Under the current US economic system, since the year 2000 more than 2 million jobs have left the country due to outsourcing, replaced by half as many low-wage, unprotected service-sector jobs.

This means all that wasted packaging is not actually a necessary and harmless byproduct of an economy that delivers a high standard of living to the most people. On the contrary, the biggest beneficiaries of a trash-rich market are those at the top. Garbage is the detritus of a system that unscrupulously exploits not only nature, but also human life and labor. Why should anyone risk their health and the survival of natural systems to enrich the world's elites? Though the rewards of a trash-reliant economy are unequally distributed, its risks affect everyone.

Louis Blumberg and
Robert Gottlieb (1989)
*War on Waste: Can America
Win Its Battle With Garbage?*
Washington: Island Press

Center for Investigative Reporting
and Bill D. Moyers (1990)
*Global Dumping Ground:
The International Traffic in
Hazardous Waste*
Washington: Seven Locks Press

Barry Commoner (1992)
Making Peace with the Planet
New York: New Press

Stuart Ewen (1996)
PR! A Social History of Spin
New York: Basic Books

Thomas W. Fenner and
Randee J. Gorin (1976)
*Local Beverage Container Laws:
A Legal and Tactical Analysis*
Stanford: Stanford Environmental
Law Society

John H. Fenton (1953)
Vermont's Session Has Budget Clash
New York Times, February 1

Kenneth C. Fraundorf (1975)
The Social Costs of Packaging
Competition in the Beer and Soft
Drink Industries
Antitrust Bulletin 20

Raymond Geuss (2001)
Public Goods, Private Goods
Princeton: Princeton University Press

Travis W. Halleman (2004)
*A Statistical Analysis of Wyoming
Landfill Characteristics*
Master's thesis, Department of Civil
and Architectural Engineering,
University of Wyoming

Catherine Lerza (1974)
Administration "Pitches In"
Environmental Action 6.2

Brenda Platt and Doug Rowe (2002)
Reduce, Reuse, Refill!
Washington: Institute for Local Self-
Reliance

Neil Seldman (1995)
Recycling—History in the United States
*Encyclopedia of Energy Technology and
the Environment*
Attilio Bisio and Sharon Boots, eds.
New York: Wiley

Neil Seldman and Brenda Platt (2000)
*Wasting and Recycling in the United
States 2000*
Athens: GrassRoots Recycling Network

Susan Strasser (1999)
*Waste and Want:
A Social History of Trash*
New York: Henry Holt

US Environmental Protection Agency,
Office of Solid Waste and Emergency
Response (2003)
*Municipal Solid Waste in the United
States: 2001 Facts and Figures*
Washington

US Environmental Protection Agency
Basic Facts: Municipal Solid Waste
http://www.epa.gov/epaoswer/
non-hw/muncpl/facts.htm

The US Labor Force in the New
Economy (2004)
Social Education 68.2

Wrap-Up for Glass (1961)
Modern Packaging 34.8

AIRSPACE

A photographic report by Pierre Bélanger describes the ecologies and economies of landfilling in Michigan.

In January 2003, the city of Toronto closed its suburban Keele Valley Landfill and began shipping its garbage across the Canada–US border into Michigan. Over the next twelve months a total volume of 2.7 million cubic meters of non-hazardous waste—a mountain of trash large enough to fill a football stadium—was initially trucked out of Canada. All told, two-thirds of the 5.8 million cubic meters of waste that were shipped to the Midwestern United States that year originated from the province of Ontario. Today that annual figure has jumped to over 11 million cubic meters of waste transported to a variety of different American landfills.

The transboundary movement of waste is not frictionless. Responding to public pressure, the US Senators from Michigan proposed controversial legislation that was primarily intended to close Michigan's borders to Canadian waste in September 2005. However, according to the North American Free Trade Agreement, this ban could not be effected unilaterally by the United States, because waste is an article of international commerce, like water or wood, and no ban can be imposed unless Canada agrees.

At the center of this wasteshed—the region defined by garbage flows—is the state of Michigan. Bouncing back from severe economic decline, the state has reinvented itself over the past decade as the base camp for some of the largest handlers of municipal solid waste in North America. This is the story of the geopolitics of landfilling in Michigan and how airspace—a logistical term that defines the maximum filling capacity of a site—underlies the industry as the primary determinant of waste operations in the Great Lakes Region.

Thanks to Carleton Farms, Pine Tree Acres, and Taro Landfills.

On December 31, 2002, Canada's largest municipal solid waste facility, the Keele Valley Landfill, received its last shipment of garbage from the city of Toronto. After twenty contentious years of operation, the disposal site was history. Its closure was celebrated by the town of Vaughan with a party: thousands of locals turned up for the free cake, free champagne, and fireworks.

The eight hundred and fifty tickets to the special $61-a-plate ceremonial dinner were sold out in less than a week. The residents of suburban Vaughan applauded the conversion of their dump into a new park and a Scottish-style country club golf course.

EXPIRED AIRSPACE
The Eagle's Nest Golf Course located on the former site of the Keele Valley Landfill, Vaughan, Canada, 2004. (Photo: Carrick Design)

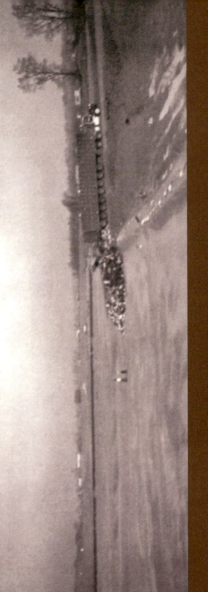

As the champagne flowed in Canada, garbage was already flowing south to the United States. The empty champagne bottles joined the 20,000 daily tonnes of household garbage that had been piling up in Toronto's transfer stations, desperately awaiting a new home. A decade of exhaustive site analysis and community consultation had failed to find a solution until Michigan came to the rescue, offering two mega-size facilities. In fact, America's largest waste management companies were more than happy to take up the challenge. Two of the biggest landfills that opened their gates to Ontario's waste were called Carleton Farms and Pine Tree Acres, names that memorialize their agricultural past.

VIRGIN AIRSPACE
The first shipment of garbage received in Cell no.1 at Carleton Farms in southeastern Michigan on 5 May 1993, 8:48 AM.

Recalibrating the laws of supply and demand, Michigan capitalized on the huge capacity of its landfill sites—the abundance of its airspace—to become a magnet for all the solid waste in the Midwest. When strict new environmental standards were enacted by the United States Environmental Protection Agency in 1991 many small landfill operators, unable to sustain the required capital investment, shut down. Large waste management companies responded by radically increasing the scale of their operations. Most companies looked beyond state and national borders for new waste streams to offset rising capital costs. Suddenly, Ontario became Michigan's best friend.

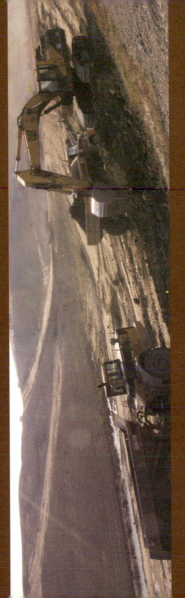

AIRSPACE UNDERBELLY

From the bottom up, the engineering of airspace relies on the careful preparation of a landfill's sub-base. Shaped like a giant bathtub, the stratified sub-base consists of five layers: 3 meters of natural clay, 60 centimeters of recompacted clay, a 2-millimeter-thick high-density polyethylene (HDPE) liner, a double-sided geocomposite drainage blanket, and, to top it off, 60 centimeters of granular material (Shown is Carleton Farms Cell no. 302).

Airspace management depends on split-second timing. Everything moves fast and everything operates on a first-come-first-served basis. Before dawn, sometimes as early as 4:30 am, an average of fifty trucks from as far away as Central Ontario and Wisconsin will be idling at the gates of the landfills, waiting to dump their first load in time for another round trip before lunch.

RUSH HOUR

The active offloading area located at the base of Cell no. 16 at Pine Tree Acres, 4 October 2005, 7:02 AM.
Without any traffic markers or directional signage, counterclockwise circulation is an implied ground rule.

With one truck arriving every three minutes, turnaround times are critical. The cycle between arrival and departure depends on the speed at which material can be dumped and then spread out to make way for the next hauler. This is where dozer operators are essential. At close to 70 tonnes each, diesel-powered D12 dozers waste no time flattening and compacting the new surface. As soon as garbage hits the ground, it becomes a building material.

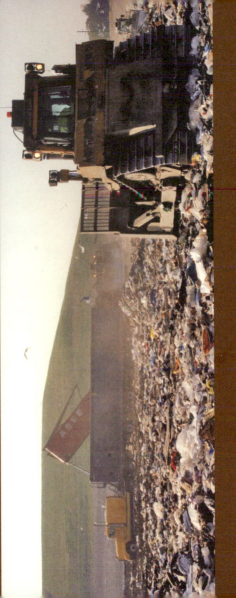

OCCUPATIONAL SYMBIOSIS

Through triangulation, dozer operators guide truck drivers with visual signals and sound cues as they back their rigs onto the edge of the tipping face at Pine Tree Acres, Cell no. 16, 4 October 2005, 8:24 AM.

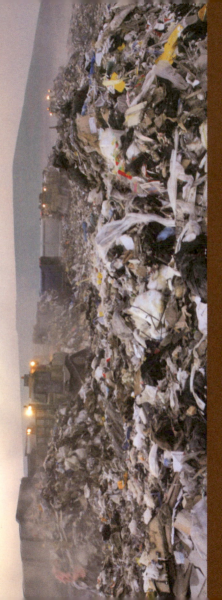

Dozer operators in Michigan are renowned for their rapid-fire turnaround times. The faster the trucks dump their loads, the more trucks the dozers can receive. The more trucks they can receive, the more business the landfill attracts. Efficient cycle-times result in time-cost savings. This is the operational ecology of airspace in its purest form.

OROGENESIS, OR THE TECTONICS OF MOUNTAIN-BUILDING
Three dozer operators lay the base course of Cell no.16 in the shadow of what will be a 91-meter elevation, 4 October 2005, 7:38 AM.

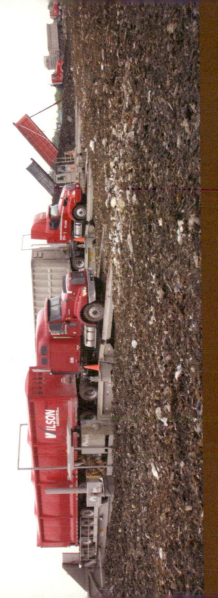

Specially designed waste tippers help to further speed up the process. These machines work with all kinds and sizes of trucks, guaranteeing customers high levels of access. Offloading time for a traditional semi-trailer equipped with a built-in hydraulic moving-floor used to be 28 minutes. A customized scale-tipper shaves 19 minutes off that time, taking it down to nine minutes flat.

TIPPING AS SCIENCE AND ART

The box trucks from Wilson Logistics' iconic red fleet, once the exclusive hauler for the Greater Toronto Area, create a ballet on the tipping scales of the active offloading face at Carleton Farms, 18 June 2005.

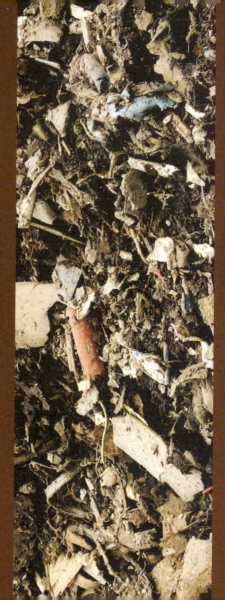

A refined scrap material called auto fluff uniquely supports the speed of operations. A byproduct of Detroit's automotive scrap industry, auto fluff is a mixture of all the different foams, plastics, and rubbers from scrapped cars: everything but the steel. Applied as a daily cover, auto fluff works as a multi-functional surface. It reduces odors and prevents wind-blown debris, but its most important function is to prevent rutting and flat tires. Time is the most significant operating cost in the business of waste hauling; fewer flat tires means less downtime and less downtime means more round trips: one waste material in service of others.

GARBAGE AS ROAD-BUILDING MATERIAL
A close-up view of a freshly laid auto fluff.

Fully mechanized and electronically automated, airspace in Michigan is the zenith of twenty-first-century technology. With global positioning systems, machine crews can guarantee surface grades to within two and a half centimeters of the level required, with impressive precision, at any second of the day. With onboard satellite systems and surface design software, machine operators become all-in-one architects, engineers, graders, and surveyors: "We're like artists, building the biggest, most beautiful mountain in the world. From the seat of a D-12 CAT, it's nice to be precise. . . ."

THE SCULPTORS OF AIRSPACE
Digitally guided dozers and compactors work on the tipping face of Pine Tree Acres, Cell no. 24, 48 meters above grade level, 4 October 2005, 11:27 A.M.

The quest for speed also breeds ingenuity. The landfill industry has even invented its own specialized truck: the "Michigan train." Outlawed in Canada and in every other state in the US, the "train" is Michigan's waste-hauling vehicle par excellence. This 42-wheeler bears a lead (the front trailer) and a pup (the rear trailer) mounted on eleven axles with a total capacity of 22,680 kg, almost twice the legal limit of any other truck on the road on the continent. There's only one drawback: the crushing damage it inflicts on the surface of the roads.

AUTOMOTIVE INGENUITY

A "Michigan train," the biggest and longest vehicle allowed on the road, offloads auto fluff in Cell no. 13. Pine Tree Acres Landfill, 6 October 2005, 7:24 AM.

Airspace volume also depends on the rate of compaction, and recirculating water on compacted waste is critical. Solid waste is 30 to 40 percent liquid that ends up filtering through the strata of garbage over time. Called leachate, this liquid collects at the base of individual landfill cells in sumps and is continuously evacuated to limit its depth on the bottom of the landfill. Leachate is then pumped through double-walled piping systems to large double-walled holding tanks in a central location. Leachate is then recirculated back into the active layer of the disposal cells to increase the compaction rate. The process never ends.

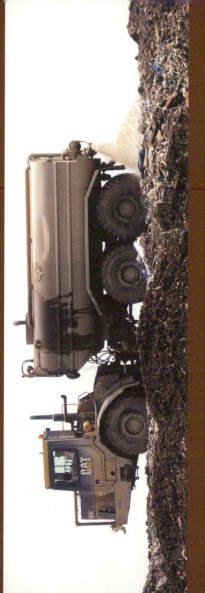

AQUACULTURE

A tanker truck irrigates Cell no. 209 with liquid leachate, the water solution that naturally percolates through the strata of a landfill as a result of settling and decomposition. Carleton Farms Landfill, 6 October 2005.

Maximizing airspace maximizes gas production. Under anaerobic conditions, recirculating leachate produces landfill gas. Carleton Farms and Pine Tree Acres have become energy generators, harvesting their own methane as a secondary commodity. Over a hundred cubic meters of gas is produced every minute for a total of 453,000 cubic meters every day. Piped out of the landfill, the gas powers generators that convert it into electricity. The 10.4 megawatts of energy produced from methane combustion each year at Carleton Farms is fed back into the Detroit Edison Grid, providing enough electricity to supply over 10,000 homes every year. Landfills are a classic example of thermodynamics: garbage becomes gas and gas becomes energy.

THERMODYNAMICS

The byproduct of airspace, landfill gas is collected in wells using a negative pressure vacuum system that sucks the gas from the decomposing waste. Comparable to natural gas, the landfill gas produced at the Carleton Farms facility is considered excellent for combustion, with its rich concentration of methane (60 percent), carbon dioxide (37 percent) and other trace gases. Any excess gas is flared to prevent explosions or chemical damage to the cap liner.

Airspace produces tax revenues. Shaving $1.50 off every 907 kg (1 ton) of garbage, economically disadvantaged counties in Michigan are benefiting significantly from foreign garbage, receiving about US$4 million every year, a figure that amounts to half their annual budgets. Canadian garbage in Michigan is directly subsidizing basic rural infrastructure; since 2003 it has paid for a new town hall in Lennox, a new fire station in Sumpter, and road repairs throughout the state. Like alchemists, landfill operators are literally turning Canadian shit into gold.

AIRSPACE HAZARD

Will Carleton Road is the main service link between Carleton Farms and Interstate 73. With a frequency of about one truck every minute during regular daylight business hours, it is rather surprising that only one person has been injured on this two-lane road in the past ten years.

Airspace in Michigan is so lucrative that in 2001 software baron and billionaire Bill Gates cashed in on the action to become the largest shareholder of Republic Services, Inc., the owner and operator of Carleton Farms in Michigan and fifty other landfills throughout the United States. Earnings for Microsoft have dropped steadily over the last decade, but shares of Gates's waste-handling portfolio have risen 45 percent over the past five years. Betting on trash seems to be a good hedge (source: US Securities and Exchange Commission).

AIRSPACE WASTESHED
Proportional garbage flows into Michigan from neighboring states and provinces in the Great Lakes Region (background photo: courtesy of Google Earth). Called "the Wolverine State," Michigan's motto, "If you seek a pleasant peninsula, look about you," expresses pride in its natural pre-existing beauty.

The business of airspace has its opponents. With the rise of transboundary waste movements in the late 1990s, Michigan Senators Carl Levin and Debbie Stabenow joined forces with Congressman John D. Dingell to put an end to the legacy of what they called "Michigan as the dumping ground for ever-increasing amounts of Canadian trash." Landfill operators in southeastern Michigan see things differently: "We love Canadian garbage. It's really easy to compact because it's really dry. It's dry because the Canadians compost almost everything." One question that hasn't yet been thoroughly answered is what to do with landfills once they are closed. Parks and golf courses are always possible uses, but with increasing pressure to urbanize surrounding areas, planners are looking for alternative options. The sheer size of the mountains that are created by the industry presents unique design challenges; the residual topography of landfilling will be one of the lasting monuments of the North American Empire.

THE UNITED COLORS OF AIRSPACE

The two-and-a-half-square-kilometer area of landfilling activity at Carleton Farms is delineated by constructed wetlands to the west, land owned by competitor Waste Management, Inc. to the north and east, and active agricultural farms to the south. The light brown areas at the top show the V-shaped sub-basins under construction. Brown areas in the center show the active open tipping faces; dark brown areas show linear compost piles; and the dark gray area in the lower right shows the ash monofill from the Detroit Incinerator; stockpiled for future use. (Aerial photo from 365 meters above the ground, 2002.)

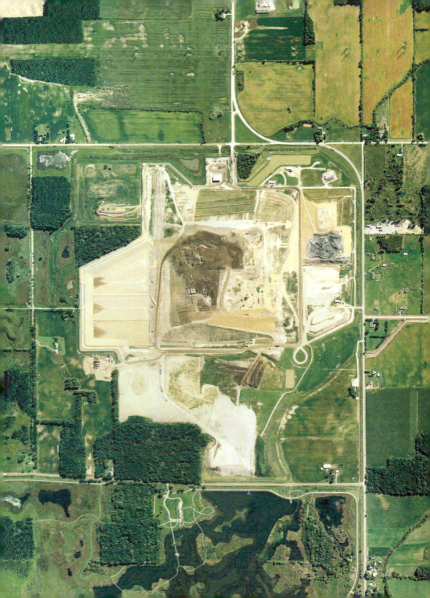

The rise of Michigan to the top of the airspace empire was both natural and predictable. Five factors underlie its supremacy. First, its geology: Michigan is endowed with a thick, practically impervious layer of Devonian clay that covers almost the entire state, an advantage its northern and eastern neighbors, with their fractured bedrock, do not share. The second factor is its location: Michigan is at the geographical center of the Great Lakes region, bordering on four states and the province of Ontario; operators throughout the state capitalize on this proximity by situating large landfills as close as possible to the state borders. Michigan's third advantage is scale: an abundance of airspace and the streamlining of operations have given Michigan a competitive edge, with rock-bottom landfilling prices. Dumping in Ontario was about US$100 a ton in 2005, compared to a cost in Michigan of about US$10. The fourth factor is NAFTA. Like water, garbage is considered a primary commodity and is protected by the Trade Agreement: state governments do not have the authority to halt the stream of garbage. Fifth and last of Michigan's advantages is its law concerning future use: operators in Michigan are only required to maintain landfills for thirty years after closure; landfills in Canada must be maintained and monitored for at least a century, or, in some cases, forever.

AIRSPACE URBANISM
An oblique aerial view shows how agricultural land uses and residential housing projects are spreading, in an almost serene and picturesque manner, around Carleton Farms. At 38 metres above grade, its current elevation represents less than half of its maximum regulated airspace, 2003.

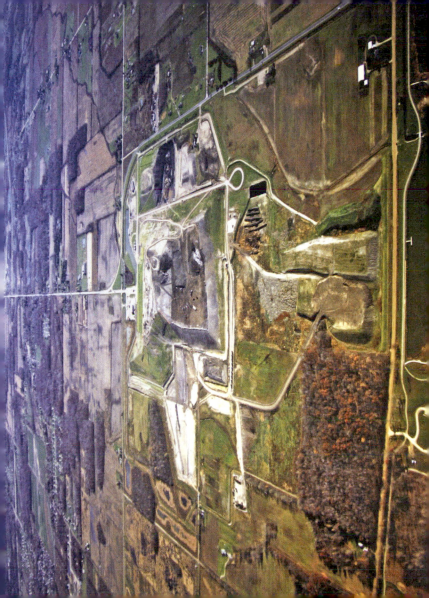

The truth is, there is no hiding airspace. At Carleton Farms, what started out as a three-meter excavation will turn into a ninety-meter mountain, irreversibly transforming the landscape of Sumpter Township. As an earthwork, its location is ideal. Carleton Farms sits directly on the flight path of Detroit's International Airport. From the air, the landfill is visible on the right side of the plane about three minutes after take-off, and on the left side three minutes before landing. An aerial view may make it clearer that mass-landfilling can only be resolved at the source, with consumers and manufacturers.

THE GIZA OF AMERICA
Carleton Farms Landfill at the end of the Will Carleton Road entrance, on axis with Cell no.1, 36.5 meters above grade, 14 October 2005. When completed, the landfill will be ten times the size of the Great Pyramids in Egypt.

When Carleton Farms reaches capacity in 2030 it will be capped and closed. The only visible feature remaining will be its airspace, filled out in three dimensions: a mundane silhouette with a 4:1 slope. Beyond its banal appearance, airspace in Michigan is the physical evidence of a distinctively anthropogenic land use: landfills have been technically engineered over thousands of years to minimize footprint and maximize vertical space. In other words, airspace is the culmination of a cultural and technological evolution. Ideologically contentious but extremely practical, the handling and consolidation of airspace in Michigan is, among other things, a highly effective strategy to counteract the mass wasting of horizontal landscape that is symptomatic of North American patterns of low-rise urbanization, and it may, over time, prove to be one of the most ecologically sound land-use strategies in the history of the New World.

BIONIC SURFACE

A 4:1 side-slope with protruding gas wells at Pine Tree Acres. 21 October 2005. Subtle shifts and buckling of a landfill's top surface are the visible effect of subsidence, the continuous settling of materials contained within the landfill. It is estimated that subsidence, like gas production, will continue some thirty years after the capping and the closure of the landfill.

MEDIA
IN THE DUMP

Jennifer Gabrys reports on the residues
from our digital devices.

DIGITAL DEBRIS

If you dig down beneath the thin surface crust of Silicon Valley, you will find there are deep strata of earth and water percolating with errant chemicals. Xylene, trichloroethylene, Freon 113, and sulfuric acid saturate these subterranean landscapes undergirding Silicon Valley. Since the 1980s, 29 of these sites have registered sufficient levels of contamination to be marked by the United States Environmental Protection Agency as Superfund priority locations, placing them amongst the worst hazardous waste sites in the country. In fact, Silicon Valley has the highest concentration of Superfund sites in the US. What is perhaps so unexpected about these sites is that the pollution is not a product of heavy industry, but rather of those seemingly immaterial technologies that facilitate the processing of information. Of the 29 Superfund sites, 20 are related to the microchip industry. Computers and mobile devices, microwaves and digital cameras: the manufacture of components for these technologies contributes to the accumulation of chemicals underground. Mutating and migrating in the air and earth, these barbed and toxic compounds will linger for decades to come.

Silicon Valley is a landscape that registers the terminal, but not yet terminated, life of digital technologies—a space where the leftover residue of electronics manufacturing accumulates. Yet this waste is not found only where electronics are produced; it moves and settles in circuits that run from manufacturing sites to recycling villages, landfills, and beyond. While we often overlook the elaborate infrastructures required for the manufacture and disposal of electronics, these spaces reveal the unexpected debris that is a byproduct of the digital. Electronics, or digital technologies,

often register only as "media," or as interfaces, apparently lacking in physical substance. Yet the waste from digital devices reorders our understanding of these media and their ecologies, revealing spaces where the residue of electronics congeals and disperses. When digital devices turn up in the dump, we can begin to re-map their reach through their remainders.

ELECTRONIC WASTE

"Waste is now electronic," writes Gopal Krishna, describing the escalating number of obsolete electronic devices headed for the dump. Here is the other side of electronic waste—not a byproduct of the manufacturing process, but the dead product headed for disposal. E-waste—trashed electronic hardware, from personal computers and monitors to mobile phones, DVD players, and television sets— is, like the electronics industry, growing at an astronomical rate. In the US, it is expected that by 2010, 3 billion units of consumer electronics will have been scrapped at a rate of 400 million per year. The volume of obsolete electronics is so great that in the near future the number of outmoded computers is projected to surpass the number produced or consumed (IAER; Kuehr and Williams). Of the hundreds of millions of computers declared useless, at least 75 percent are stockpiled, according to the US Environmental Protection Agency. Computer owners store the outmoded model as though there might be some way to recuperate its vanishing value, but the PC is one item that does not acquire value over time. At some point, stockpiled computers enter the waste flow, and are either landfilled, recycled for reuse, or shipped for salvage to countries with cheap labor and lax environmental laws. The Digital Revolution, as it turns out, is littered with rubbish.

SILICON ELEPHANTS

Contrary to popular perception, digital technology is hardly light or dematerialized; rather, as Silicon Valley makes evident, it involves elaborate systems of abundance. Worldwide, discarded electronics account for as much as 20 to 50 million metric tons of trash per year. Such a volume of discards is equivalent to the disposal of 1,000 elephants every hour (Nair). A colossal parade of elephants—silicon elephants—marches to the dump and beyond; suddenly the immaterial abundance of digital technology appears deeply material. For example, the manufacture of semiconductors requires tremendous material inputs; as much as 99 percent of the material used in making semiconductors is discarded. Raw materials, chemicals, and water are disposed of in order to arrive at the impossibly pure and miniature microchip (Mazurek 48). Bits and shards, gallons and tubs, are dumped down the drain or stored as waste matter in underground tanks. The waste and contamination particular to electronics is, for this reason, often initially invisible, only to return later in material form: obdurate, shapeless, toxic. Today's proliferating digital technologies necessarily produce an equally gargantuan and diverse plume of pollution. Abundant chemicals, abundant materials, abundant devices, and abundant pollution and trash; the attempt to dispose of all this waste simply transforms one type of abundance into another. Yet the elephantine scale of production ensures that at some point and in some corner of the world, the discards will resurface.

EPHEMERAL SCREENS

Before it becomes trash, however, digital technology drives another type of abundance, this time in the dematerialized space of electronic

trading. The National Association of Securities Dealers Automated Quotation System (Nasdaq) is the electronic trading system that specializes in technology companies, and it is also the world's first electronic stock market. Established in 1971, the Nasdaq is now the world's largest "electronic screen-based equity securities market." The Nasdaq, an index of the volume and value of digital technology, is itself a digital technology. As a system of automation programmed to deliver financial data across a scattering of sites, its telecommunication networks enable market activity to take place among "thousands of geographically dispersed market participants" (Smith et al. 98–101). In this sense, the Nasdaq network is located in a million micro-locations, from individual screens to stories-high display screens in Times Square, to the massive server farms that collect and disperse data.

This market, an electronic trading space, hovers in a virtual space of instant exchange. But, like Silicon Valley, this seemingly immaterial space is rooted in matter, and in waste. The Nasdaq is the economic and technological engine that contributes both to the increasing volume of shares in digital technologies, and to their rapid rise and fall in value. The virtual ticker tape of financial data displays information that is obsolete at the moment of its appearance. This is the speed of trading: instant refresh, enhanced execution time, all traveling through sophisticated and constantly updated computer and telecommunication networks. This system generates automated remainders both in the program of instant information, and in the form of proliferating electronic technologies that support the monitoring and exchange of technology shares. The seemingly dematerialized marketplace, in the end, is an instant refuse generator, both in terms of its own erratic valuations, and in terms of the material fallout from obsolete technologies.

SHIPPING AND RECEIVING

These obsolete electronics linger in warehouses, in attics, and on curbsides, awaiting disposal. Here is a rapidly growing industry with equally rapid waste streams. The Basel Action Network, or BAN, an organization that tracks the movement of e-waste, writes, "the electronics industry is the world's largest and fastest growing manufacturing industry, and as a consequence of this growth, combined with rapid product obsolescence, discarded electronics or e-waste, is now the fastest growing waste stream in the industrialized world" (5). In the end, transportable electronic waste follows the path of the most undesirable forms of trash—from economically privileged country to poorer one. The primary exporter of electronic waste is the US, a country that does not consider the export of waste to be illegal. But electronics from the United Kingdom to Singapore turn up in places as far-flung as China, India, and Nigeria.

Because of investigative research done by BAN, much attention has been directed to one particular region in China, Guiyu, in the Guangdong province, where cheap labor makes the stripping of machines for salvageable parts profitable. Here, thousands of workers break down the discarded electronics for raw materials, including gold, steel, and copper. Electronic components are burned and dipped in acid baths to remove metals, while materials not worth salvaging are incinerated or dumped in the surrounding region (Shabi). These recycling methods are toxic for both workers and the environment. Soon, however, this garbage may circulate indefinitely, searching for a final resting spot, as countries such as China are currently regulating against accepting shipments of electronic waste. We can imagine barges of dead electronics trolling the oceans, unable to land to unload their toxic shipments, caught in a peripheral and restless space of remainder.

FAILURE IN THE ARCHIVE

For every ton of electronic material cast out, a select portion ends up preserved in the halls of history. Alongside the dumpster are those spaces where artifacts are preserved as markers of significant cultural moments. Significance derives from the sheer everydayness—and pervasiveness—of materials like electronics. The archive, in this sense, is a dustbin, a collection and stockpiling of "representative technologies" that flooded and continue to flood the market. Much of the technology in the electronic archive is inaccessible: ancient computers do not function; software manuals are unreadable to all but a few; spools of punch tape separate from decoding devices; keyboards and printers and peripherals have no point of attachment; and training films cannot be viewed. Artifacts meant to connect to systems now exist as hollow forms covered with dust. In this sense, the archive can be seen as what Will Straw calls a "museum of failure": it is a record of failed and outdated technologies. If it collects anything, it collects a record of obsolescence.

The idleness of these electronic artifacts raises other questions about how technology demarcates duration. The archive attempts to fix time, and in so doing reveals the rapid rate of change that is endemic to digital technology. Bound as it is to systems of continual reinvention, digital technology cannot slow down to fit into the archivist's slow time. The dilemma of preservation collides with the dilemma of electronic waste. How does one preserve media that have a built-in tendency toward their own termination? When we insert these failed objects into the archive, we encounter their impermanence in high relief. So while collections and lists of "dead media" proliferate (see Sterling), the archive suggests that electronic technology is not so

much dead as always dying; that expiration, even more than innovation, is the ceaseless activity that electronics perform.

THE DUMP

Most electronics are not chosen for preservation, however. Instead, idle machines, at end of life and end of utility, stack up in landfills, are burned or buried. More formally known in the Western world as the "sanitary landfill," the dump is the penultimate site of decay, where electronics of all shapes and sizes commingle with banana peels and phone books. Plastic and lead, mercury and cadmium break down and begin their terrestrial migrations. Electronics—media in the dump—require geological time spans to decompose.

The dump is a site where objects typically devoid of utility or value collect. Except through the work of invisible salvagers, from mice to treasure-seekers, the material here is unrecoverable. The "garbologist" William Rathje suggests the best way to investigate contemporary material culture is through this apparently useless garbage (see Rathje and Murphy). Much as archaeologists study the relics of the distant past, Rathje unearths the refuse of the "non-historical" past to measure human consumption. This garbology examines cultural phenomena by linking discarded artifacts with consumption patterns. Garbage Project crew members set out to landfills to draw core samples, tabulate and catalog discrete waste objects, and thereby chart significant patterns of consumption. In this sense, a dump is not just about waste, it is also about understanding our cultural and material metabolism. A dump registers the speed and voracity of consumption; the transience of objects and our relation with them; and the enduring materiality of those objects.

Digital technologies linger in the dump, where they stack up as a concrete register of consumption. The garbology of electronic waste may have an obvious reference point in landfills, but from Silicon Valley Superfund sites to recycling villages in China, we find an even more expansive global network of waste sites where electronic debris expands, sifts, and settles. Electronics, media, landscapes, and waste are all linked and in constant transformation. From the virtual to the chemical, and from the ephemeral to the disposable, the accumulation of these electronic wastes creates new residual ecologies, and requires expanded practices of garbology. With electronic waste, we can begin to look beyond the thin surface of digital interfaces to find that the movement, transformation, and accumulation of this debris belie the myth of immateriality. In the dump, our digital media and technologies turn out to be deeply material.

Jane Meredith Adams (2003)
Silicon Valley's Tech Waste Problem
Chicago Tribune January 28

Basel Action Network and Silicon
Valley Toxics Coalition (2002)
Exporting Harm:
The High-Tech Trashing of Asia
Seattle and San Jose

International Association of
Electronics Recyclers (2004)
IAER Electronics
Recycling Industry Report
Albany

Gopal Krishna (2003)
E-Waste: Computers and
Toxicity in India
Sarai 3: Shaping Technologies

Ruediger Kuehr and
Eric Williams, eds. (2003)
Computers and the Environment:
Understanding and Managing
their Impacts
Dordrecht: Kluwer Academic
Publishers

Jan Mazurek (1999)
Making Microchips:
Policy, Globalization, and Economic
Restructuring in the Semiconductor
Industry
Cambridge: MIT Press

Dipti Nair (2005)
Jumbo Junk
Deccan Herald July 3

William Rathje and
Cullen Murphy (2001)
Rubbish! The Archaeology of Garbage
Tucson: University of Arizona Press

Rachel Shabi (2002)
The e-waste land
The Guardian November 30

Jeffrey W. Smith, James P. Selway, III
and D. Timothy McCormick (1998)
The Nasdaq Stock Market: Historical
Background and Current Operation
NASD Working Paper 98-01
NASD Economic Research
Department: Washington, DC

Bruce Sterling
Dead Media Project
www.deadmedia.org

Will Straw (2000)
Exhausted Commodities:
The Material Culture of Music
Canadian Journal
of Communication 25.1

DR. STRANGELOVE

DR. STRANGELOVE

Kristan Horton recreates—in tiny trash
assemblages—frames from the Kubrick classic.

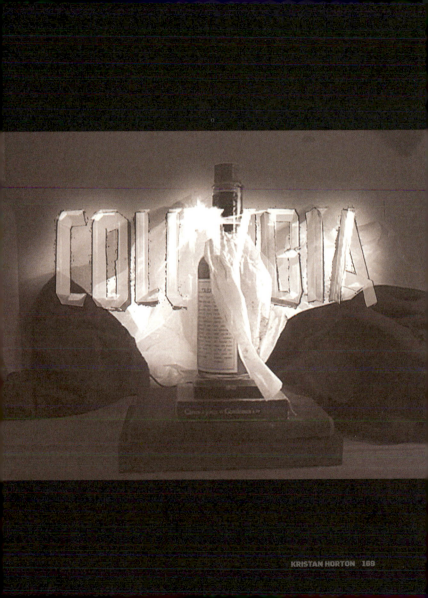

GEORGE C.
SCOTT

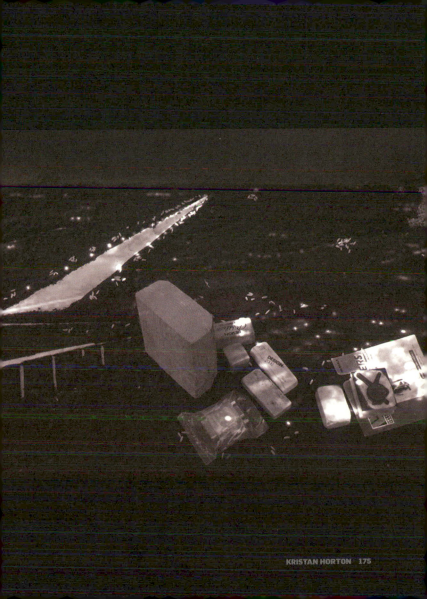

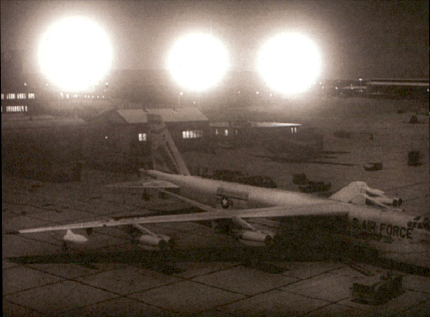

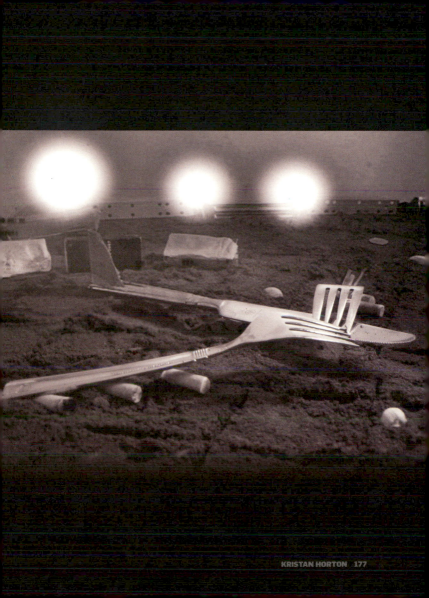

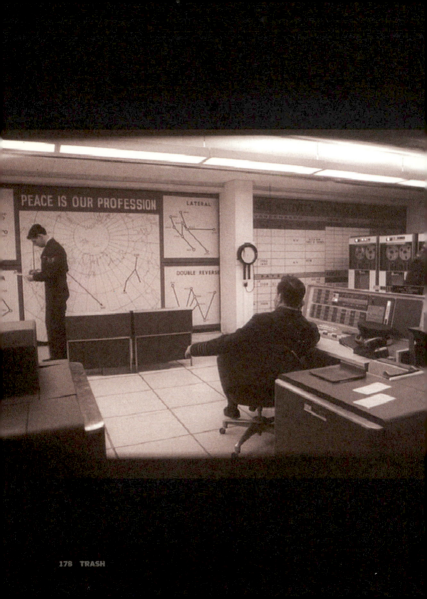

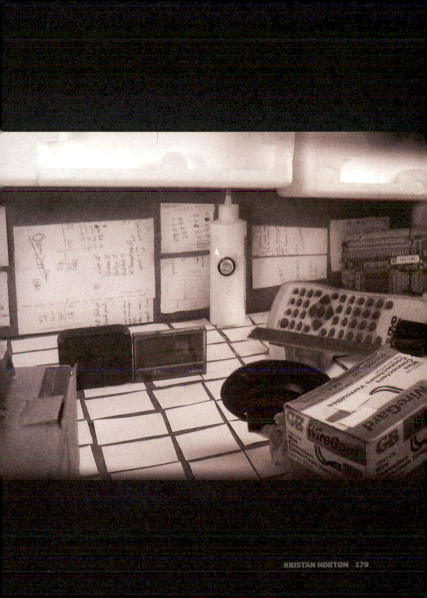

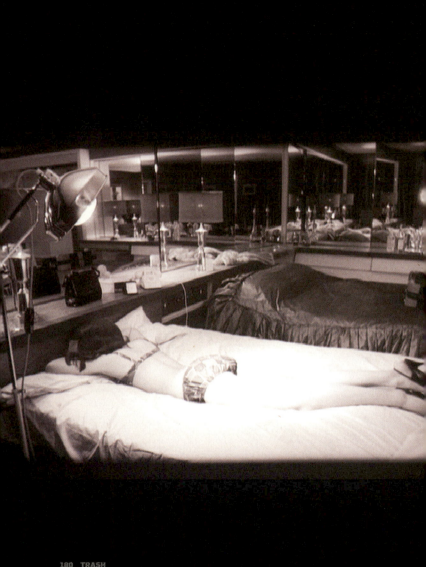

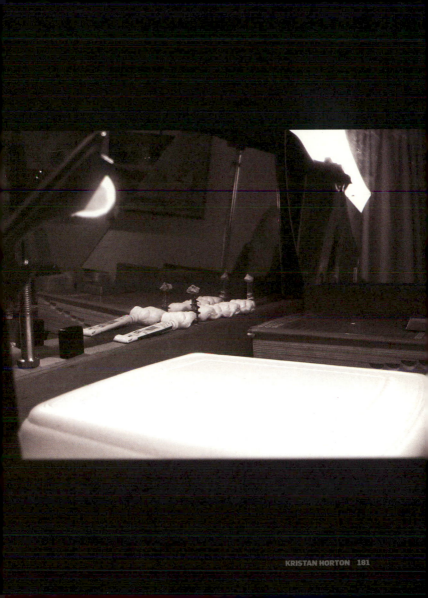

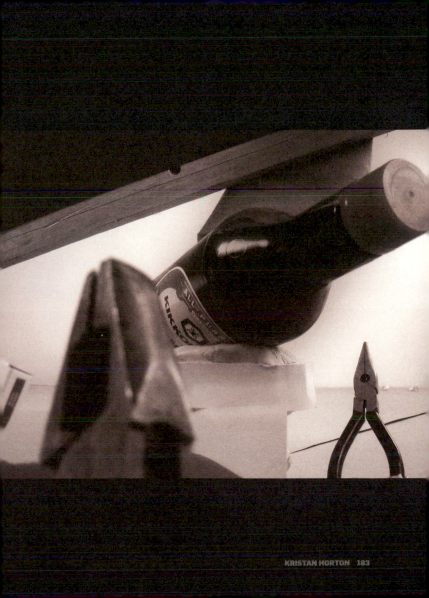

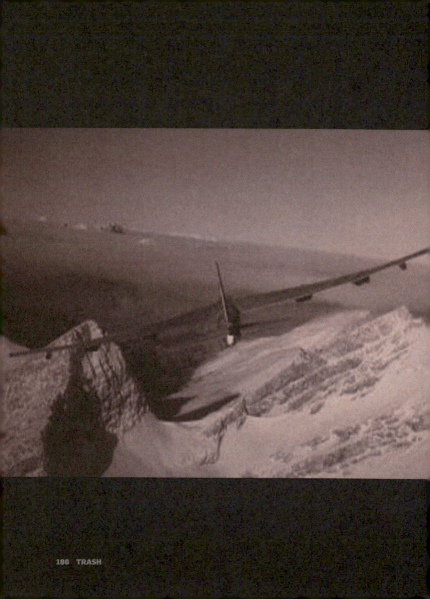

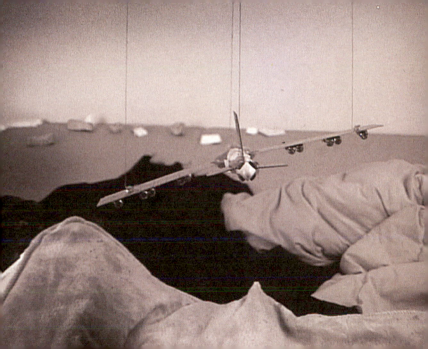

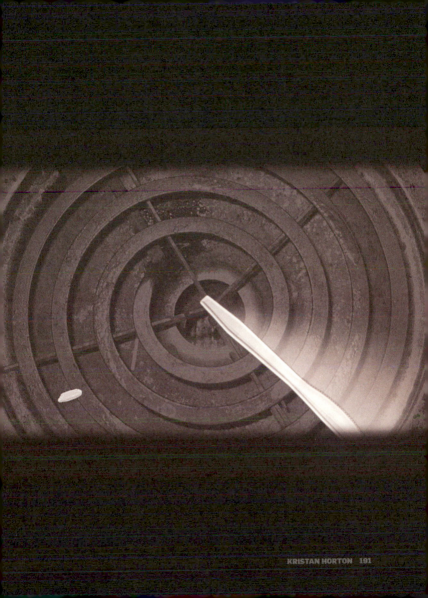

BOMB DOORS

OPEN

CLOSED

DOOR INDICATOR

4

BOMB DOORS

9

DES MALADIES DE LA BOUCHE

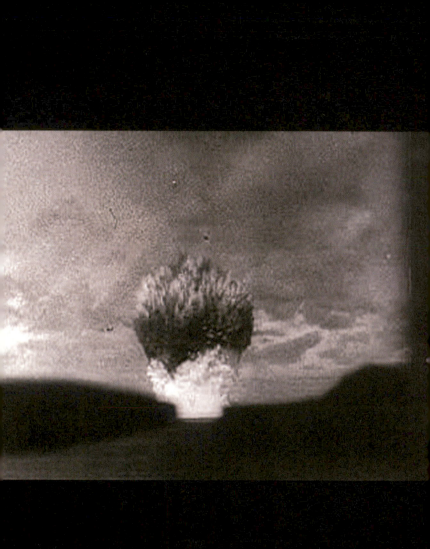

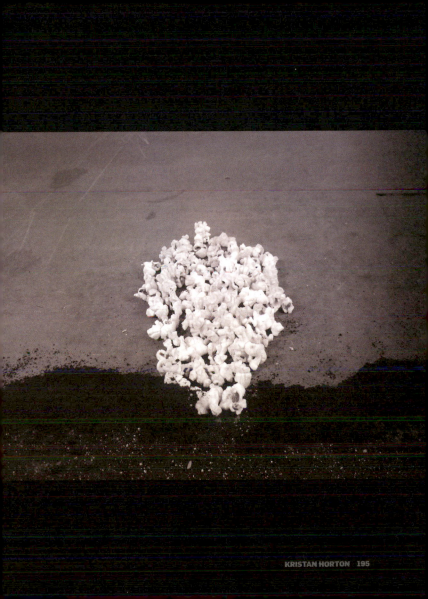

THE ETHICAL ARTIFACT: ON TRASH

Trash marks the limits of knowledge,
argues Barry Allen.

HISTORICAL TRASH

The most impressive thing about our trash is how well made it is. A plastic juice container tossed in the trash is astonishingly well made: the regularity of the surfaces; the fine hard ridges of the screw-top; the elegant fusion of bottom and walls, all rendered in a light, transparent medium. Or think of a polystyrene fast-food container, used for seconds, then discarded. Imagine the astonishment of a Leonardo da Vinci encountering such an object. How was it made? What is its material? How were the colors applied? What is the source of the exquisitely regulated workmanship? Yet to us, it is incidental utility and enduring trash.

Why is our trash so well made? Primarily, because it is mass-produced in conditions of industrial automation. Leonardo would look at a polystyrene container through the lens of a culture whose manufactures depended almost entirely on the ability of the individual workman to manage the unpredictable qualities of the material he had: a workmanship of skill and risk. Practically nothing was made with the kind of certainty that we routinely extract from automated artifice (see Pye).

Trash is what it has always been, quotidian refuse. But the nature of trash is changing fast. Over the last five thousand years it has become increasingly urban, and now, with globalization, urban trash is nearly all the trash there is. Moreover, in the last two centuries trash has become first industrial, then technoscientific, as industrial production has merged with technology and science. Trash is now technological. Drive around neighborhoods on garbage day in a large city: at the curbside, you'll see television sets, old speakers, daisy-wheel printers, video monitors, even entire computers. Sometimes they're broken and not worth repair. Sometimes they're just unwanted. Even when

malfunctioning, they remain exceptionally well made. The detail, precision, joinery, materials, and finishes are unique in the history of detritus.

Mass production and automated industry have significantly changed the composition of trash. They, in turn, are dependent upon urbanism and civilization, which I understand by contrast with the idea of culture. *Culture* is a one-word epitome for the artifactual economy (symbolic and technical) that sustains any human community. It is present wherever humans are. It is the practical, artifactual matrix that shelters every human group. Civilization is different. It is the historical event—or series of events—that introduces the civic into a human culture: the event of the city, of urbanization. World civilizations are products of the diverse transmutations that diverse cultures have undergone in cities.

The difference between technology and technical culture is akin to that between civilization and culture. A civilization is an event in the history of culture. Technology (technologizing) is an event in the history of technical culture, or technics. Humans have depended on technics since the first stone tools were fashioned by the first species of the genus *Homo* some two million years ago. An important difference between human tools and the so-called tools of chimpanzees is that the chimpanzees could easily survive without them, while for us some level of technical culture is a precondition of biological existence. Imagine people like us trying to live in the wilderness with not so much as a knife or the use of fire.

However, technology is not just tools or technical culture. It is a series of events in the history of technical culture. It happened first in Britain in the 1770s. The Industrial Revolution in manufacturing was accompanied by the rise of engineering knowledge and the first polytechnics (in France). The sociotechnical economy of, first, Britain,

then western Europe, then America, and now the world, began to change. It began to base itself on the technological. This came as the result of crossing a threshold. More and more of what we were making with tools and machines was other tools and other machines, or their parts and accessories. Following the Industrial Revolution, machines have increasingly been made with other machines in mind as much as the humans who will operate them. Artifacts depend on ever vaster networks of *other artifacts*. Consequently, more of what is made is designed to take other artifacts—the machine-machine interface—into account. Machine-machine relations have become at least as important as the human interface.

An example I like to use is the Boeing 747 aircraft. It has 4.5 million parts. Its design required 75,000 engineering drawings (Petroski). The very being of a high-tech artifact like the 747 presupposes innumerable layers of artifactual interaction, linking the plane to passengers, metallurgy, petrochemicals, telecommunications, engineering schools, and so on. Without all the mediators, it cannot fly, and becomes no more than high-tech trash.

Technological trash is well made because technological artifacts consigned to the trash are mass-produced and made to interface. Imagine noticing a computer card—say, an old modem—undamaged, in the curbside trash. *Someone* could conceivably use it or at least recycle its electrical components. But it is generally cheaper to buy such components new, and recycling integrated circuits and micro-chips is practically impossible. So this computer card is trash.

Examine the worthless thing. Its high level of finish and diversity of materials reveal it as urban, as civilized, as mass-produced. Consider how much of it is designed to connect to another machine. As a modem, it mediates between the telephone line and the computer's central processing unit (CPU). That is a matter, at the level of circuitry,

of multiple connections and rapid switching across all contact points. This circuitry is carefully tuned to standard protocols for both the CPU and the telephone line. There is practically nothing about the card that is not technological, in the sense of having been made in anticipation of other machines with which it must be more or less directly coupled. It is that coupling that probably got the modem trashed. Technically, it works fine. The circuitry is intact; it still does exactly what it was designed to do. It is trash because changes in everything to which it must connect have made it unusable.

A shift in technical economy to favor replacement over repair explains some part of technological trash. Not many of us in North America would bother to repair a seriously malfunctioning television. If it was under warranty, we would return it; if not, it's probably trash. Yet I remember a time when every television was repaired. Television repairmen came to your home to do it. I remember their fascinating tool boxes, the lids folding out to reveal a selection of vacuum tubes.

Repair is not necessarily a bad thing to have to do (Spelman). It is good to live in a world that *can* be repaired, in which artifacts are *worth* repairing. A world where things are well made is likely to be in constant need of upkeep. A world where things are badly made, where nothing is worth repairing, is a throw-away world of indifferent replacements. The gesture of repair is a refusal to admit that art and knowledge have reached their limit, that no more can be made, no more done, with a thing. It's like refusing to let a person die. Nevertheless, more and more often, what makes our works work is a technological black box that one must simply replace. The failed unit may be recyclable in part, though there is always a surd for the trash. Technological artifacts are thus constructed in anticipation of other artifacts, themselves anticipating others, so that they are highly

vulnerable to obsolescence well before they fail. They become the best-made trash in history.

SEMANTIC TRASH

Semantically, trash belongs with garbage, junk, rubbish, refuse, debris, and waste. Trash is more like junk than garbage. Garbage is organic. It's formless and it stinks. Rubbish is particulate: dust, shards, cigarette butts, bottle caps. Trash, like junk, is often clean, a matter of well-made paper, plastic, and metal. Like junk, trash includes the malfunctioning, failed, burnt-out, and obsolete. If there's a difference, junk tends to be unwanted yet usable, while trash is used up, spent, exhausted, or obsolete. That's why there can be junk shops and junk sales but not trash shops and trash sales. Something can be unused, or even unusable, without being trash, for example, a cloud. But the cloud never was usable. Trash once was. Trash always has a past, a use that is spent. Like an old person.

That exhausted utility distinguishes trash from other artifacts in a state of desuetude, such as rubble or sacrifice. The rubble of war is not trash. It wasn't used up but destroyed. And only unbelievers believe sacrifice is wasted. Trash is also different from objects that have been contaminated. An implement may become useless not from damage but from actual or ritual pollution, from radioactivity, for example, or in some cultures from the sullying touch of a low-caste person. The result is not trash but a polluted, dangerous thing, an artificial corpse that requires ritual care. Finally, the *trashy* is not literally trash (not *in* the trash), but ought to be. The reason is usually that it is poorly made, inferior, derelict, squalid, cheap.

Is there natural trash? The idea of "nature" is problematic. Understanding the word as commonsensically as I can, it seems clear

that there can be no natural trash. To be trash, something has to be used up. Trash therefore posits a telos, a use, a design, and there's none of that in nature. Nothing in nature is ever used up because nothing is, strictly speaking, *used*—that is, existing by design, for a purpose or telos. Pardon my atheism, but nature is not an artifact. Nothing in nature has an end, purpose, or design. And what wasn't *made to do* anything at all cannot break, malfunction, or become obsolete, spent, or exhausted. So there is no trash in nature.

Of course, one reply to this argument is that since trash exists, it is natural. Indubitably. So too are artifacts, and everything we call artificial. They're all nature too, all outcomes of the evolution of life. But that doesn't mean there is no significant difference between what is an artifact and what merely happens to exist, because artifacts happen to have rather singular conditions of existence—nothing less than human socio-technical economy. I won't say trash is unnatural, since nothing is. But I do say it requires this economy, which implies human beings, practices, cultures, *ars* and *techne*. Where there is no artifice—no art and knowledge—there is no trash.

The processes of life are unintentional, ateleological, without purpose. Trash is not like that. Trash is the spent remnants of works of design and artifice. Isn't our power of design itself an outcome of evolution? Yes, ultimately. But art and knowledge are products of life that overstep life's productivity. The principal force of evolution is natural selection by the conditions of existence, otherwise known as survival of the fittest; but with the evolution of artifice, an agency has appeared that is capable of arresting, redirecting, or setting aside that principal force. There is nothing impossible or even uncommon about evolution producing a power capable of interfering with the forces by which life evolves. T. H. Huxley made this point in his famous lecture "Evolution and Ethics." His example was gardening.

Gardening is antagonistic to the cosmic process of evolution, despite being an outcome of that process. So is getting your tonsils out, or wearing eyeglasses. As a Darwinian, Huxley believed that the cosmic process was one of intense and unceasing competition. But gardening eliminates struggle by removing conditions that give rise to it. Eyeglasses do the same thing. It is the ubiquitous effect of art and knowledge. From their union all good things are born, and also trash.

AT THE LIMIT OF ART AND KNOWLEDGE

Where knowledge is potent, artifacts are recycled, used instead of trashed. Only when knowledge is weakened by reaching its current limit does trash appear. Trash is generated where knowledge ends. And knowledge, what's that? Orthodox ideas of knowledge have never been more untenable (Allen 2004b; 2005; forthcoming). Such views confine knowledge to propositions, judgments, veridical belief, or mental representation. Orthodox views emasculate knowledge by demanding that it be true, a logical condition only a proposition can meet. The best knowledge, on these accounts, is linguistic, logical, theoretical, and (it is seldom noticed) *written, graphic*. Orthodox views present knowledge as orthodoxy, insisting that any knowledge be "justified," which means reducing it to something familiar, established, orthodox. Why untenable? This logocentric point of view mystifies the connection between our "knowledge" and the historical accomplishments of technological society. The ingenuity of our technical culture, the depth of technical mediation, the multiplicity of the interfaces in a global technoscientific network: all of that bespeaks profound knowledge. But it isn't the application of a theory, it cannot be formalized in a canonical notation and seldom takes the form of

an indubitable truth. The "knowledge" of epistemological philosophy is scarce on the ground in technological society. And what *looks* like knowledge in technoscience is far different from epistemology's logocentric linguistification.

That knowledge must be "true" is a longstanding presupposition of Western thought. Yet there are many instances of knowledge that cannot be called true. A surgical operation or a bridge can be as good examples of knowledge as any truth of science. Nor are such cases exceptional. Knowledge does not merely include artifacts, it *is* artifacts more than anything else, and such knowledge, not being propositional, cannot be subject to the discursive conditions that only a proposition can meet.

Knowledge is a quality of artifacts, not of all but of some, the most accomplished. I call this quality superlative artifactual performance. Not every use of an artifact exemplifies knowledge. It doesn't take knowledge to use a payphone—only habit. But the creation of artifacts, artifactual innovation, and everything that is well done, well made, and technically excellent about artifacts, is evidence of knowledge, the work of knowledge, the art of knowledge. Knowledge exists in technically accomplished artifacts before it is represented in the mind. The accomplishment that distinguishes knowledge is not a representational or cognitive one; it is *technical*, the performative quality of an artifact.

To explain knowledge as superlative artifactual performance is not a statement about an essence or pure concept. Rather, it explains knowledge in terms of its good, its value, the human point of caring to know. Nietzsche put the question with his usual bluntness: why know—why not rather be deceived (455)? My answer is that to see the good of knowledge, we must look at superlative artifactual performance. To understand why knowledge makes a valuable

difference to our experience, think about the relationship between human existence and our capacity for superlative artifactual performance. The global human environment is more densely mediated than ever before by complicated, interdependent artifacts. The more we cultivate knowledge, the more our environment assumes this character; the more it does, the more effective knowledge becomes.

Trash is the artifactual surd confronting knowledge at its limits. Something is trash when it is spent, exhausted, used up. It becomes that the moment a person can no longer use it. What are you supposed to do with the paper cup your french fries come in after you have eaten? Fold it up and take it home? Keeping it would be more trouble than it's worth. You would soon have a houseful of empty containers. No, you're *supposed* to throw it away. The only way it would not become trash is if somebody knew how to convert it to a resource. Therefore what stands between us and our trash is the limitation of current knowledge. In what we consign to the trash, we confront the current limits of ingenuity, the current limits of art and technical economy. The once useful artifact stares back at us with dull inutility, and we look for a place to toss it. It's harmless now and then, but when *billions* are served it becomes a problem: everybody's problem.

Ultimately, trash is what's really costly about exchange. If I exchange A for B, someone else exchanges B for A. We pay each other's costs. B costs A, which I give the other; A costs B, which the other gives me. Accounts balance. But not everything made can be exchanged. There is always debris, an inutile surd. Trash is a product of exchange that is not exchangeable, since to exchange trash is to eliminate it, to convert it to a resource. Kitchen scraps and excrement are waste only when they are expensive to produce. If they are instantly recycled in a garden compost they are resources, not trash. The proof of trash is

the cost of doing anything with it, even leaving it alone. Anything you do with it has an unrecoverable cost, and you have to do something, because doing nothing is making a choice too.

Could there be a trashless economy? Thermodynamics may suggest otherwise. It is also unclear that a trashless technology would necessarily constitute progress. A technology could only become trashless by becoming so radically simple that its debris disintegrated into the soil. That is the "technology" of chimpanzees, not advanced human beings. So, far from being progress, it would probably be a prelude to extinction. Ecologically, however, trash *per se* is not a problem. The problem is its cost, especially the cost of urban, technological trash. With urban density now practically worldwide, trash has entered the ranks of a global ecological agent.

Must there be trash wherever there is *ars* or *techne*? It seems inevitable. There will always be trash as there will always be tragedy, since knowledge is always limited. As Prometheus said, "Art is weaker than Necessity" (Aeschylus). Trash doesn't have to be expensive, though. The problem with our current trash is that it is too expensive. We cannot master trash, as we cannot master death, by a decisive act of knowledge, but we can be more intelligent about trash, consider it more, care more about consigning work to the trash. We need to be more ingenious and artful about trash so that the art and ingenuity upon which so much depends don't cost so much.

MORAL TRASH

We mourn rubble. Who mourns trash? Is the loss less wasteful? The cost less a concern? Not anymore. Not when trash becomes urban, technological, global. Witnesses to the rubble of war, we mourn human short-sightedness, willfulness, evil. Even "justified" rubble is

mourned: that it had to come to that. Would we act better, more justly, if we had better knowledge? That has been the conviction of Western philosophy since Socrates, who insisted, to general incredulity, that vice is no more than ignorance. Anyone who knew better would automatically act better. Maybe war is ignorance. Trash certainly is. Anyone who can convert trash into a resource is guaranteed a reward. Therefore the reason we do not do it must be that we don't know how. Or just don't care? Or don't care to know?

Trash is money, of course. We pay contractors to dispose of it. Insofar as it is not recycling, however, paying for waste management is spending on the spent, the most unproductive expenditure imaginable from a long-term perspective. Not that that restrains an economy like ours, premised on indifference to the long term. The whole ethics of artifacts concentrates around the morality of trash. Trashing is something we do to artifacts, a moral act involving them even more intimately than in their original appointed use. When we use artifacts, we are caring for them. When we trash them, we withdraw care. To withdraw care from something for which we are responsible is a moral act, and it is a moral *problem* because artifacts don't stop needing care just because they can't be used. Even as trash—especially as trash—they require costly care. The largest human structure on the planet now is a landfill, the Fresh Kills site on Staten Island (Homer-Dixon 56).

Trash may be nonhuman, but it is an intensely socialized artifact. It is nonhuman, inasmuch as it cannot talk; but it is also a highly refractory participant in our economy. Any artifact is. Artifacts cooperate or throw up obstacles. They impose their programs, compel respect for their integrity. They are so much a part of our knowledge, economy, and evolution that we can hardly exclude them as indifferent to our values. Trashing something doesn't exile it from the

commonwealth. It may be spent, but it still counts, because it still importunes and still requires care. Trash is a moral problem because artifacts are moral beings. They count, too. As Bruno Latour writes, "morality is from the beginning inscribed *in the things* which, thanks to it, *oblige us to oblige them*" (2002, 258).

A moralist might say that morality is only for humans, not for artifacts, because only humans possess intrinsic moral dignity. Artifacts can't have intrinsic moral dignity. It is perfectly appropriate to treat them as mere means. Trashing artifacts is immoral only if it harms other people. I would agree that, yes, artifacts lack inherent moral dignity, but so do humans. An inherent moral dignity reserved exclusively for us would be an unnatural discontinuity, fallaciously setting humanity apart from the rest of living nature. It is an impossible distinction in any understanding of evolution. Genealogical continuity links practically every organism on earth. You and the cows in a Big Mac are kin. You haven't shared an ancestor in several million years, but that's just a number, and doesn't support a categorical distinction, as if the suffering of cattle simply couldn't matter. In a world where everything alive is bound by countless threads of ecological interdependence and common descent, species membership carries no moral weight (Rachels; Allen 2004b). Dignity is a moral achievement of individuals, not a generic human birthright.

What we call morality is a folk name for what a natural historian might call our social instincts. Humans are intensely social primates with similar social instincts. These include a predisposition to sympathy and a strong biological need for a group to whom we can be loyal. Most of moral feeling begins there. With experience and understanding, we can expand the circle of sympathy and altruism, from clan or tribe to nation or humanity at large. We may extend morality to other animals, even trees, even artifacts. We recognize members of

other species primarily because they suffer. But if, like trees or entire species, they do not meaningfully suffer, they may still count, or can be made to by their spokespersons, who tie humans and trees together in a common future.

The case is just the same for artifacts. For instance, the artifactual sources and byproducts of electrical power: the fuel burned, the radioactive waste produced, the effects on the atmosphere, the potential biohazard or terrorist threat. All of that matters, and has to be taken into account. The artifacts of electrical power can no more be morally discounted than a murder. We have to count artifacts because they impose themselves; they don't just disappear merely because we no longer know how to use them. Instead, they become trash, which is always a net loss—and increasingly a dangerous one.

Isn't such care ultimately for our good, not theirs? Artifacts have no good, no *connatus*, no will to live. Well, not without us. But neither have we without *them*. Human beings can no more exist without artifacts than without fresh water. Any good we pursue is so densely crisscrossed by applications of artifice that we have little or no idea what a "good" is that is not artifactually mediated. The artifacts are there, then, with us, with the good, from the beginning and until the end. Just like other people. Artifacts like the ozone hole or the nuclear power plant at Chernobyl are *players*. They reveal the autonomy of artifacts in relation to will and knowledge. They do not have a will of their own. But their effects cannot be mastered by will, or art, or knowledge; Art is weaker than Necessity, and artifacts have a necessity of their own, a necessity they throw up at the limit of knowledge.

Our good has to include peaceful coexistence with sometimes unruly artifacts. Trash gathers along the fault lines of this coexistence, where artifacts become uncooperative, fail to work, and yet still require care. What does morality require in our relation to artifacts?

I think Latour defines this well: "To maintain the reversibility of foldings is the current form that moral concern takes in its encounter with technology" (2002, 258). The reversibility of foldings is, in a word, recycling. We make things, and make things of things we've made. Every artifact, especially the technological artifact, folds countless others into the black box of its effectiveness. Ideally, we can reverse these folds, recover materials to then fold into other assemblages. Trash begins where this reversibility is stymied. To withdraw care at that point and discard a thing is like letting a person die. Sometimes there's no choice. In a different world, the person might not die; there might be the knowledge to save him. When we trash a thing we withdraw care, not usually for callous reasons but because we have no practical choice, and that is a failing of knowledge. You *have* to throw the french fries container away. No one knows what else to do with it since, sadly, it was made that way, made to defeat the very knowledge that designed and manufactured it.

Works can be made to recycle, designed to cooperate with this alternative, instead of being made (as they increasingly are) with indifference to reuse. Design has little alternative (nor has humanity) to becoming much more serious about reuse and recycling at every possible level. Knowledge has to catch up with its own works, and design for the day when things can't work as designed and have to be, not trashed, but retired from service and gracefully recycled. There's nothing immorally obsolete about an item that can no longer fulfill its original function when it can be recycled into works elsewhere. Whatever the work, whatever it is made of, the more of it that can be *folded back* into renewed *techne* the better.

Of course, such an art of design will not appear merely because the survival of the global system of civilizations depends on it. Neither can market forces be guaranteed to discover it before older

ways take us over the ecological brink. What will it take to make us feel the failure of art and knowledge that trash implies, to feel it as a problem, a problem of art, of knowledge, of artifactual morality?

It is, as I said, probably impossible to become trashless. The challenge, however, is not to become trashless but to make trash for which we can care. What matters is not trash *per se* but its cost. The best trash is trash we are prepared to care for. We care for trash not just by waste management but by taking care not to trash for trifling reasons, or to make things that can *only* be trashed after one cycle of use. Trashing artifacts is like the end of life. It is inevitable. It is also a morally sensitive transition, and should be negotiated civilly with the nonhuman beings whose fate has intertwined with our own.

Aeschylus (1995)
Prometheus Bound
George Thomson, trans.
New York: Dover Books

Barry Allen (2004a)
Evil and Enmity
Common Knowledge 10

——(2004b)
Knowledge and Civilization
Boulder: Westview Press

——(2005)
Knowledge
*New Dictionary of the History
of Ideas*, vol. 3
Maryanne Cline Horowitz, ed.
Detroit: Charles Scribner's Sons

——(forthcoming)
Turning Back the Linguistic Turn
in the Theory of Knowledge
Thesis Eleven

Thomas Homer-Dixon (2001)
*The Ingenuity Gap: Facing the
Economic, Environmental, and Other
Challenges of an Increasingly Complex
and Unpredictable Future*
Toronto: Vintage Canada

T. H. Huxley (2004)
Evolution and Ethics
*Evolution and Ethics and Science
and Morals*
Amherst: Prometheus Books

Bruno Latour (2002)
Morality and Technology:
The End of the Means
Theory, Culture & Society 19

——(2004)
*Politics of Nature: How to Bring the
Sciences into Democracy*
Cambridge: Harvard University Press

Friedrich Nietzsche (1967)
The Will to Power
Walter Kaufmann and
R. J. Hollingdale, trans.
New York: Vintage Books

Henry Petroski (1990)
*Invention by Design: How Engineers
Get from Thought to Thing*
Cambridge: Harvard University Press

David Pye (1978)
The Nature and Aesthetics of Design
Bethel: Cambium Press

——(1995)
The Nature and Art of Workmanship
Bethel: Cambium Press

James Rachels (1990)
*Created from Animals:
The Moral Implications of Darwinism*
Oxford: Oxford University Press

Elizabeth V. Spelman (2002)
*Repair: The Impulse to Restore
in a Fragile World*
Boston: Beacon Press

PROTOTYPES

Brian Jungen dissects and reassembles consumer products in order to simulate more ancient forms.

From the collection of the Vancouver Art Gallery; photo 1 by Tomas Svab, photos 2–4 by Trevor Mills.

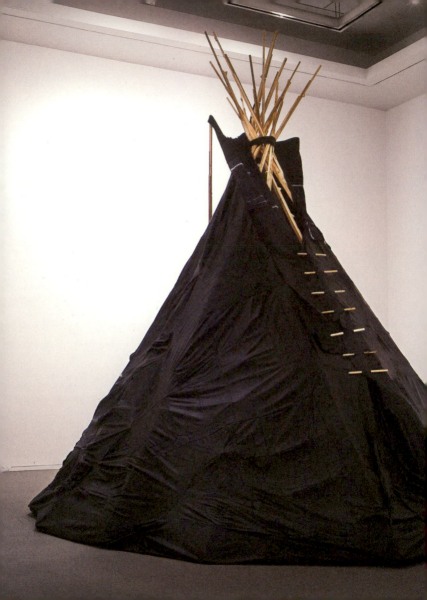

**PROTOTYPE FOR
NEW UNDERSTANDING #2** 1998
Nike Air Jordans, human hair

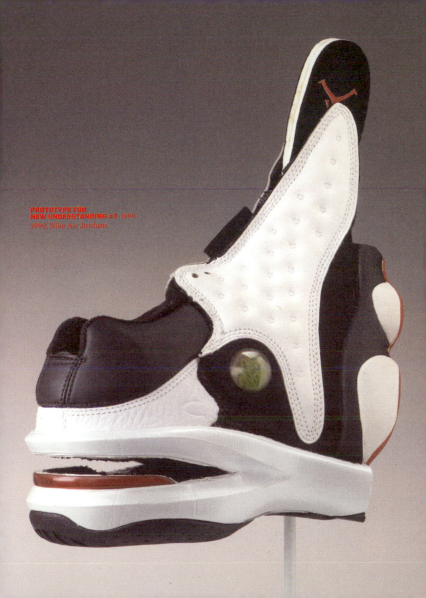

**PHOTOTYPE FOR
NEW UNDERSTANDING #3** 1999
1999, Nike Air Jordans

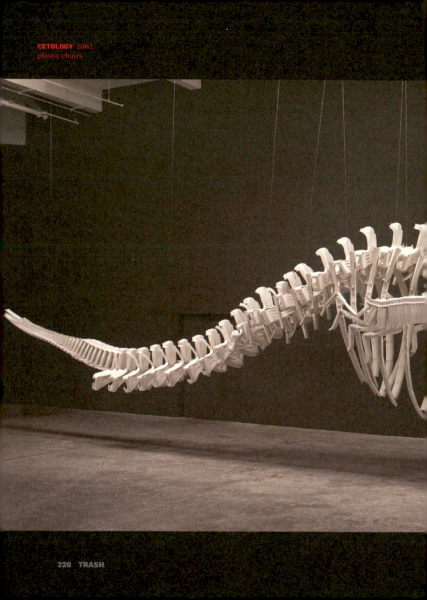

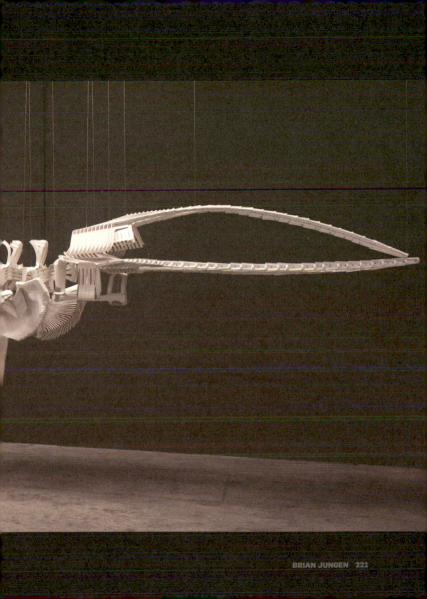

UTOPIA GLEANERS

Gleaners help us find the utopian
energies of what has been cast aside,
says Tina Kendall.

On April 22, 2001, the streets of Buffalo, New York, were taken over by a group of "anarchist" protesters, a self-styled army of "trash can warriors" known collectively as the Garbage Liberation Front (GLF). Armed with shopping carts, flags, banners, and their mascot, the "giant liberation rat," they stooped to conquer the city of Buffalo, picking up litter, recycling what they could, and erecting a tire swing for neighborhood children. Their mission? To expose the scandal of the disposable logic of consumer capitalism, which stimulates economic growth by encouraging wanton wastefulness.

In their "Communiqué No. 1" they insist that what passes for trash in our contemporary consumer societies is "rarely waste." Rather, they maintain: "Garbage is a lie. . . . Why are dumpsters locked? Why do compactors destroy food when so many remain hungry?" For activist groups like the GLF and other such communities of dumpster divers, saving useful goods from the trash is a way of life, a protest, and a means of mobilizing social action against the environmental and socio-economic consequences of our society's heedless wastefulness.

In these groups' informational forums online, dumpster diving is often framed as an urban adventure, a hobby, or even a meditative practice like fishing. It is understood as an activity that enables a new relationship to the everyday, with trash functioning as a kind of threshold permitting passage from the mundane to the marvelous. A community called the "freeganist" movement advocates dumpster diving as part of an environmentally and socially responsible lifestyle, which recognizes that "in a complex, industrial, mass-production economy driven by profit, abuses of humans, animals, and the earth abound at all levels of production."

But in the GLF's "Communiqué" trash collecting is given a meaning that transcends economic or environmental activism. They assert that "We are the reconstruction workers, come in the name of

liberation to demonstrate the power of community, the beauty of diversity, and to allow for the freedom of all. WE ARE PICKING UP THE TRASH OF FREE TRADE." The utopic message of the manifesto is clear: the Garbage Liberation Front aims to liberate much more than our trash; it desires the "freedom of all" from the tyrannies of "capitalism gone mad," and proposes a utopian ambition: to imagine the new kinds of social relations that might emerge from a changed relationship to waste. Trash is framed here as something that holds a utopian residue of hope that might be channeled into a social critique.

The signatories of the GLF manifesto are not the first to speculate about the utopic possibilities of trash—its hidden energies that are ripe, as it were, for the picking. The figure of the trash collector has a long and complex history; the image of the modest person who heroically or selflessly stoops to gather what others have refused has itself often been "picked up" by artists, writers, filmmakers, and cultural critics, and invested with exactly this kind of utopian resonance. The cultural critic Walter Benjamin places a great deal of faith in the power of collecting. For him, every collector is a potential revolutionary, but none so radical as the *chiffonnier,* or ragpicker. In formulating his theory, Benjamin draws on the writings of Charles Baudelaire, for whom the *chiffonnier* was one of the heroes of modernity. Ragpickers were marginalized figures of the mid-to-late nineteenth century, classed amongst Paris's growing population of homeless and poor, who earned their living by scavenging the streets and collecting the refuse produced by the emergent processes of industrial capitalism. Although largely disdained as a dirty tramp by the popular imagination of the time, the ragpicker was reclaimed by Baudelaire as a key figure for understanding and defining the experience of urban modernity.

In his essay "On Wine and Hashish" Baudelaire pauses to contemplate the ragpicker's relation to the new culture of consumption and waste that was then taking shape: "I have sometimes thought with horror that there were labors that brought no joy, labors that brought no pleasure, worries without comfort, sorrows without recompense." Confronted here by the increasingly grim realities of modern urban life for the most disadvantaged workers, Baudelaire is moved to melancholic despair. But he soon corrects himself, saying: "There I was wrong. [The ragpicker] is responsible for gathering up the daily debris of the capital. All that the city has rejected, all it has lost, shunned, disdained, broken, this man catalogs and stores. He sifts through the archives of debauch, the junkyards of scrap. He creates order, makes an intelligent choice; like a miser hoarding treasure, he gathers the refuse that has been spit out by the god of Industry, to make of it objects of delight or utility" (7). The ragpicker's task is the Sisyphean one of sifting through all that his age has deemed useless and thrown away. Much more than just a victim of socio-economic circumstances, though, Baudelaire's ragpicker is an agent of redemption who converts trash to treasure, an unofficial archivist documenting and preserving the evidence of excess and social injustices that others pass by or choose to ignore. He finds illumination in trash, documenting the new experience of everyday life in flux; in this respect, the ragpicker bears an uncanny resemblance to the poet, who "stumble[s] over cobblestones [. . .] wandering in search of rhymes." The essence of ragpicking is creative, reimagining and reinvesting new value in what is otherwise framed as trash. The trash collector effectively "dreams" his way into a better world by reorganizing the material and the social. This is precisely the task of cultural critique as Benjamin conceived of it. The critic sifts and searches through the pile of debris that the "storm of progress" trails in its

wake, thereby redeeming objects and people cast aside as worthless by dominant modes of organizing and fixing value.

If Baudelaire's writings on the ragpicker articulate a central truth about the experience of modernity in the nineteenth century, Agnès Varda's documentary films, *The Gleaners and I* (2000) and *The Gleaners and I: Two Years Later* (2002), can be seen as a manifesto for the ways in which everyday life in our time might change in response to the call of trash. The films follow various gleaners as they go about their routines of gathering up what other people throw away. Some of them pick up agricultural leftovers deemed unfit for sale and dumped in fields or left to rot; others, city dwellers, forage for food or household goods in urban trash; and artists—like Varda herself—incorporate trash and found objects in their work. In an interview, Varda explained that the film began with her desire to address an important social issue: "I had to piece it together and make sense out of it all in the film, without betraying the social issue that I had set out to address—waste and trash: who finds a use for it? How? Can one live on the leftovers of others?"

What is perhaps most striking about Varda's *Gleaners*, however, is the fact that she declines the usual documentary filmmaker's stance of observing her subject from a safe and sanitary distance. Varda allows herself to, in her words, "live in the film, to 'let in' the film," to let herself come into contact with matter that is normally shunned and rejected, or ignored. Indeed, as the title suggests, Varda's film is also a document of herself, an act of self-portraiture, a meditation on aging and the power of film to save images from the inevitable decay of time. There are moments of introspection in the film, and an affectionate complicity between Varda and her subjects; the filmmaker foregrounds her affective responses to others and her feelings of responsibility for what others might repudiate as worthless trash.

She shows us that what we reject as trash, we also refuse as resource and as possibility.

The gleaners in Varda's films embody the kind of generosity that might be possible for all of us if we learned to see the world outside the narrow definitions of value and meaning provided by consumer capitalism. They call our attention to the hidden social connections that are so often obfuscated in the circuits of trash. She explains: "We have been so much in this civilization of being beautiful, being young, being seen, being this, being that, being rich, and consuming. And the film is totally on the other side . . . [in] tenderness and peace with people. Some people don't even look at gleaners. They see them in the gutter and they turn their head, because they think they will be ashamed. But it's the one who looks who should be ashamed, because the other one when [the gleaner] opens the garbage he can say, well stupid people who throw out everything" (Rigg).

In this, Varda's film reminds us of what Gay Hawkins has called the "relational processes that bind us to waste." In her recent book, *The Ethics of Waste*, Hawkins argues for the need to consider the ethical significance of trash in everyday life. For her, representations of trash such as those in Varda's documentary are powerful precisely because they present us with the "ethico-political" challenge of "imagining a new materialism that would transform our relations with the things we pretend not to see" (Hawkins 81). Varda responds to that ethical challenge by proposing the gleaner as a figure through which we might rethink our relations to waste. But beyond that, *The Gleaners and I* and *Two Years Later* demonstrate, as does the GLF manifesto, "the power of community" by framing a response to trash as a concern for those whose lives and livelihoods depend on it.

The Garbage Liberation Front, the filmmaker Agnès Varda, and the writings of Charles Baudelaire insist on or portray the duality of

trash as a symptom of consumer excesses and as a figure of Hope. In other words, trash can document the world as it is, but it can also open up a space for thinking in unabashedly utopian terms about the world as it might be. To say, as the GLF do, that "garbage is a lie" is to define it as the product of a false way of organizing and consuming the world. The trash collector is emblematic of the call to found an alternative relationship to trash: ragpickers, dumpster divers, and gleaners are figures who represent the possibility that people and things that have been tossed aside, neglected, or destroyed might be lovingly gathered back up and reincorporated within the social system that rejected them. The trash collector's gesture of redemption implies a generosity that encounters with trash could teach the rest of us. At their most powerful, collectors, gleaners, and gatherers document the injustices produced within the present, and in so doing they create a space for us to dream ourselves into a better future. This is what trash collectors do: by foregrounding the alienating effects of our disposable culture, they mobilize and make use of the utopic energies buried within the trashy, the outmoded, the worn-out, and the cast-aside.

Charles Baudelaire (1996)
Artificial Paradises
Stacy Diamond, trans.
New York: Citadel Press

Walter Benjamin (1969)
*Charles Baudelaire: Lyric Poet
in the Era of High Capitalism*
Harry Zohn, trans.
London: NLB

——(2000)
The Arcades Project
Howard Eiland and
Kevin McLaughlin, trans.
Cambridge and London:
The Belknap Press

Laurie Essig (2002)
Fine Diving
Salon June 10
www.salon.com

Garbage Liberation Front (2001)
Communiqué No. 1
Independent Media Center
www.indymedia.org

Gay Hawkins (2005)
*The Ethics of Waste:
How We Relate to Rubbish*
Lanham: Rowman & Littlefield

Julie Rigg (2002)
Gleaning Agnès Varda
ABC Arts Online August 21

SOUND SUITS

Nick Cave's wearable artworks are built
from found materials and make sounds
when animated by the wearer.

Nick Cave's *Sound Suits* is a collection of wearable art works constructed of found materials including sequins, old socks, twigs, bottle caps, fabrics, feathers, pinwheels, and many other bits and pieces. They are full body garments, designed to make sounds when they are animated. If the wearer is motionless, the suits are silent. What they all have in common is an arresting, sublime, and intense presence, the materials connecting us at once and in surprising ways to shamanic ritual, contemporary fashion, and, of course, trash.

Cave, trained as a dancer, wears the suits in performance. Using sound and motion, he transforms his personal identity, forging new connections with each suit every time he performs. Whether still or in motion, silent or clamorous, the *Sound Suits* open new vistas on the experience of being human.

—Camilla Singh

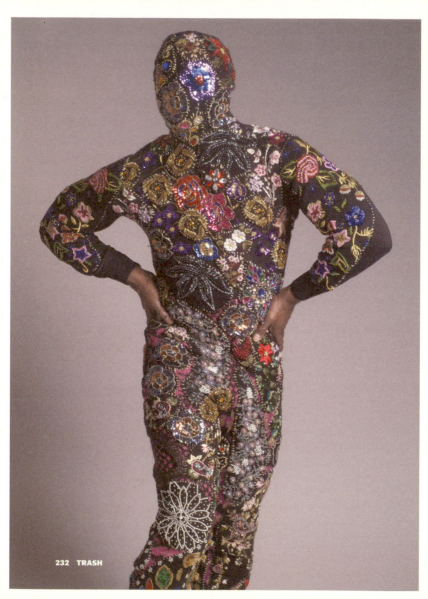

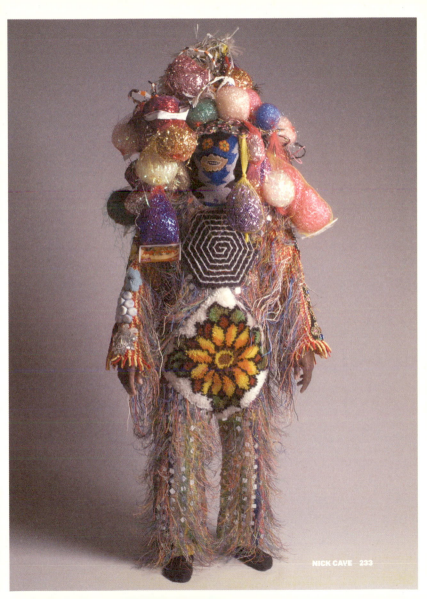

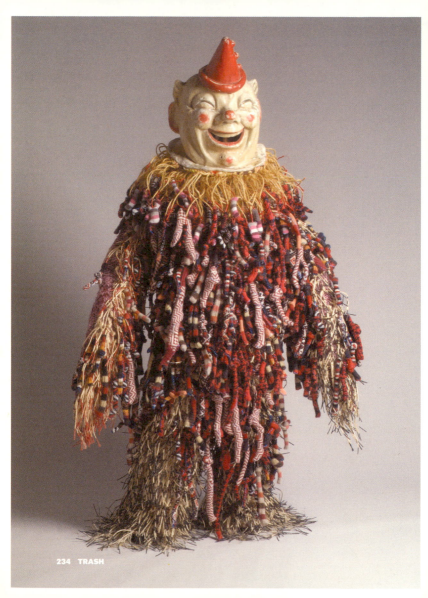

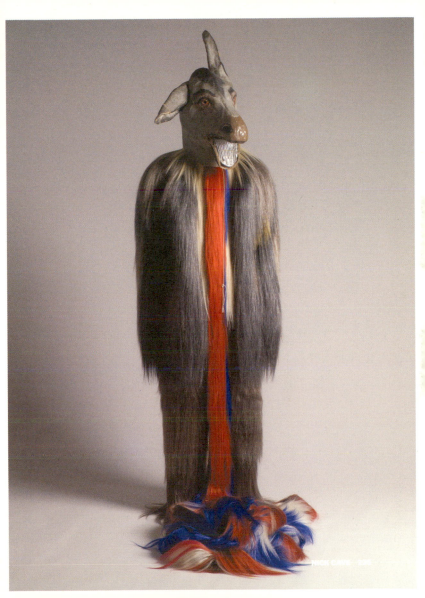

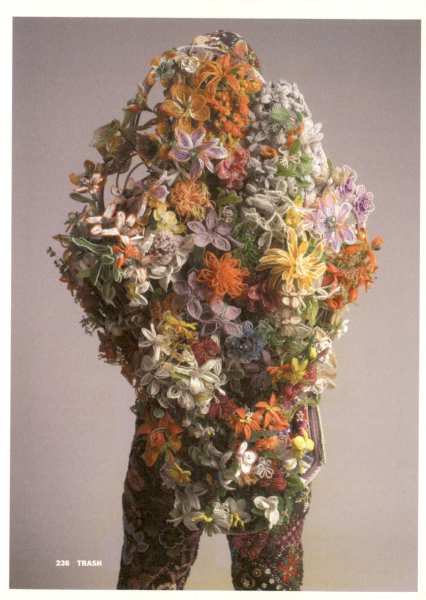

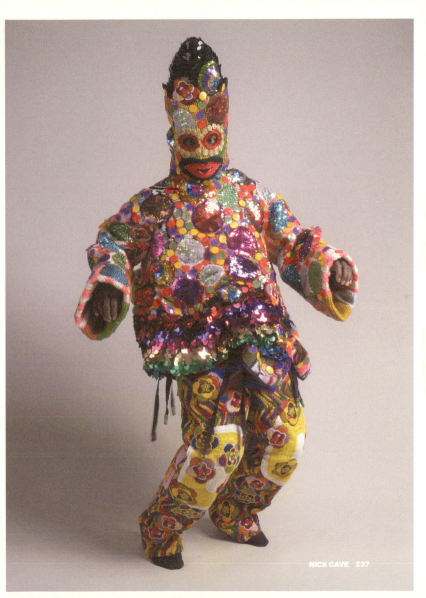

REFUSE/
REFUSED

In Priya Sarukkai Chabria's poems
the discarded—a worm, an old woman,
a shard of mirror—speak.

THREE CANTOS

1.
Hahaha, he laughs, the bald boy, veteran ragpicker who's sitting on
a pile of junk, toes splayed, while around him strays snarl or sleep,
his pets, his messengers from the world outside, bound to this dump
by its bounty, hahaha, there's nothing you can't find here, he laughs,
this mini-lord of litter, here's a part of a ladder to dreams, haha,
a broken keyboard to miracles, a magic shoe with a hole in its sole,
a silk bra of torn desires, haha, haha, and mountains of bags and
more bags that leak their stink like joss sticks offered to me, hahaha,
the city's memories are strewn at my feet like flowers of pus hahaha,
so much waste and so much want, like the cut-up girl in that bag,
that big one near the car parts, she's refuse now because she refused
to sleep with him, hahaha, this is my kingdom come, haha, this is your
kingdom come, come, come, don't refuse your part of it.

2.*

I awoke to the sound of rustling and smoke swirling from dying
campfires. The festival ground was like a cremation ghat,
deserted; I looked around, I too was deserted, the sky fell flat
on the earth, on the sacred river flowing like a distant snake.
I stood and looked around. Debris everywhere. Plastic bottles,
rags, single sandals strewn as families left in haste so as not to
awaken sleeping ones like me. And shit and smoke and the
rustling; rustling everywhere as the cold breeze blows. Rustling
billowing plastic bags; torn bags that skitter across this
desolation like abandoned dreams. Into this desolation I must
enter, not as mother, not as grandmother or aunt or sister,
for my womb's a shriveled bag, an empty purse; I walk now as
refuse that has refused family, religion, name. Strays bark
through the rustling. Into this great rustling I will walk,
make my home, become rustling, a torn plastic bag tumbling.
I don't worry.

　　　Trash has no home; it is everywhere; it haunts. Trash is the
renouncer's last desire, the last touch of homeland.

*Old widows were sometimes abandoned by poor families at sites of large religious *melas* / festivals.

3.

Still waters run deep, they say, but it's a lie, floodwaters run deeper still. See me, a giant tree stretched horizontal across the land, flowing swift, my branches cutting up suburbs, my girth spanned by bridges that I've swallowed because somewhere else too many of my kind, the standing variety that is, were cut and carted off by logger cartels so the earth on which they stood slipped and fed my greed and I spread like washed rain over windshields, blurring everything.

I spread, a slit vein over embankments, a slit vein through streets, climbed the dainty stairs of houses, pushed cars along and felt them turning into rust inside me, and still I flowed, running deep and poisoned by a thousand desires. And, like you, not satiated, though I sucked in a thousand things then abandoned them along my path, my shining path shod with inverted stars that float above streetlamps submerged. But a small thing bothers me: bags that float, that carry the rubbish of a city, this refuse that refuses to sink but blobs over my body like a wig of undulating synthetic hair.

When I recede, for my time too will come, I'll festoon ledges, trees, archways, windows, neon signs, you name it, with torn plastic bags, I'll leave the city's secrets fluttering high; as I die down I'll mark the city with its flags of life, its trash.

MIRROR TALK

A shard speaks:

Once I was intact
 though cheap. Thick glass
lined by poison, shaded a burnt orange.
A mirror one foot by one, propped
 against a turquoise wall in
 a hovel in a slum.
I had my place.
I was a wedding gift: glass flowers cut
into my borders, dreams of paradise
 drilled
in. Tawdry finery, you'd say, but who
 are you to speak?
All was fine. I saw sex, need, sleep.
Each day I was left alone, each night
I saw sawdust kindled
to make a flame, to cook a meal, I saw them eat
the rotting food spiced hot. I saw it all. I have a billon
eyes. (All mirrors do.)
Until that night when he hit her once too hard and she hit
 him with his shovel caked with grit.

He fell against me, against their dreams; I split.
I became a mirror cracked.
My body's shards were gathered up like precious rain
 before the cops came. I
was forgotten. Left behind. A piece too small, blood
staining petals of glass. I was a flower colored at last.

And now? I'm a mirror shard lodged in a dump
 too deep to gleam or cut, or,
 you could say, to make my mark.
I'm part of reclaimed land, the trash
on which this city is built.

But I'll wait my turn to shine
again in a museum's glow. Remember
the junk of Pompeii that's held up as art?
Or the clay fragment that was once a cracked toy
in Mohenjodaro, that now lies in velvet light?
 My time will come when
 yours is done.

NURSERY RHYME

Eggshell, mutton bone,
Tea leaves, peach stone

All this and more
Each day they throw
On my home.

Tomato seeds, lemon rinds,
Potato peel, coffee grounds

I grind and guzzle and
Toil and trouble my way up
Through plenty. No rest for me.

Rice grains, carrot tops,
Cake crumbs, spinach stalks

Unfazed by waste I'm on top
Of the heap. I'm blessed. I'll die
In riches, a glutton in haste.

Fish eye, goat's balls,
Lamb's blood, chicken gall

I'm Emperor of Discards. The world's
Poor are picky, that's what! Look around.
There's food galore for everyone.

Cheese scraps, jam blob,
Toast crust, ketchup splotch

I'm a slave in paradise,
A worm named "Cardinal Enterprise" living
In a cathedral of rot. Like you. Start counting....

Lettuce shred, prawn tails,
Milk drops, entrails...

THE MISSING DAUGHTERS OF JUAREZ

Rachael Cassells travels to Juarez to photograph
the mothers of murdered Mexican girls.
Interviews and translations by Esteban Sheridan.

Since 1993 more than four hundred women have been murdered in Juarez, a city on the US/Mexico border opposite El Paso, Texas. Ninety-three of the cases are considered to be serial murders. Many of the victims were teenage girls, most working-class migrants employed at maquiladoras. These manufacturing plants dot the landscape of Juarez's tax-free border zones, producing everything from plasma televisions to refrigerators. The maquilas provide steady jobs that draw migrants from Mexico's rural areas.

Suddenly, in the maquilas, young women from small rural communities can earn as much as young men. Once pious, quiet, submissive in the manner of traditional Mexican village girls, these young women arrive in a world of brothels and strip clubs whose neon lights are a trademark of the Juarez landscape. Violence against women in Juarez has grown with the city's economic boom. Most of the 423 murders have been labeled "crimes of passion": a resentful husband or boyfriend ends his partner's life.

When the first bodies were found in 1994, authorities said that the victims had been murdered for not being "properly dressed" and that they had provoked their killers. They did very little to solve those cases. The ninety-three registered (and unsolved) serial murder cases have more than once featured "lost" evidence, and police have ignored the mothers' pleas to solve the crimes against their daughters.

NGOs in Juarez believe that the authorities' slow progress in investigating the first murders inspired copycat killings across the region. If you were a man in Juarez at that time, before the international media came, and you were angry with your wife, you could kill her and dump her body in one of the many empty lots surrounding the maquilas with impunity.

In 2002 thirty-three mothers of the victims of these murders formed Mothers for Justice. They had often seen each other at the victims' funerals, and started meeting once a week. They get psychological and medical help for the families, and are a support group for the devastated mothers.

—Esteban Sheridan

Velia Tena Quintanilla
daughter Rosa Isela Tenaegos

"My daughter's name was Rosa Isela. She was only fourteen when it happened. She was lost in a neighborhood called Independencia No. 1. She was by herself going to pick up my youngest son from school, but she never made it there, and then she never came home. She was lost for three days and then they found her body in a junkyard behind some government offices. They never found who did it. Rosa was my only daughter. She would be twenty-four now. She wanted to study. She was about to start high school but she disappeared in December. She was a good girl, hardworking, loving. She liked to take care of children. I get really frustrated, but what keeps me going is that I have hope that some day they will find the murderer and I will rest. I have hope. I also want to prevent this from happening to other people. Every single time I see a murder reported in a newspaper I lose my breath. My skin crawls with anger and sadness for the girl and her family, her mother, her father, her brothers and sisters, and for the lack of justice towards poor people like us. Today, despite all the attention, the police solve maybe five percent of the crimes and that makes me very angry and anxious. You feel like your hands are tied, and that you can't do anything to stop it. It makes you angry, and anxious. It's painful because I know what happens to the families. I know their pain. Entire families are devastated. That pain stays in your heart and it never leaves. When another girl is murdered, our wounds start to bleed again. You feel like your hands are tied, and that you can't do anything to stop it. It makes you angry."

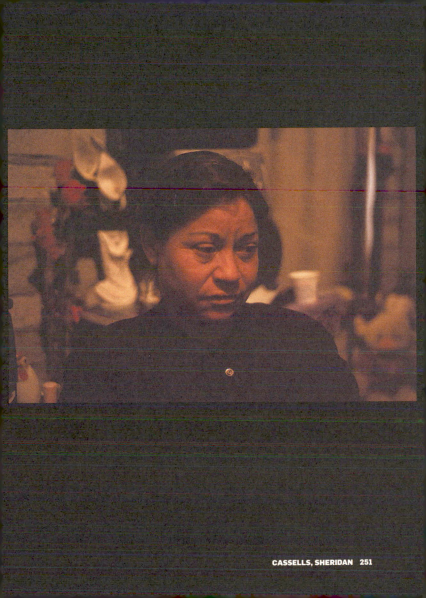

Rosaura Montañés Lerma

daughter Aracely Esmeralda Martinez Montañés

"Ten years ago my daughter was murdered. A very violent, brutal death that hurt me and my family profoundly. I was at the edge of madness. I didn't see justice so I lost faith in God, in churches, and in myself. I was afraid of everything: I was afraid of people and mostly I was afraid of cops. As time went by, where they dumped my daughter they dumped another one. The murders kept happening, one after the other. They kill a human being that was loved—they kill their whole family. She rests, but we can never rest. We haven't had any peace since our daughter's death: this is eternal pain. The police, with all their follow-ups, their losing things, their outright carelessness, they have us on a tightrope. If the girls are poor no one cares if they are missing. A girl from a higher social class is much more valuable. Money is more important than a human being who lives in poverty, let alone a poor girl. If it had been the governor's daughter they would have been caught, and not a scapegoat, but the real criminal. The government hasn't done anything. Not the one before, or the one before that, or the one now. When we were going to ask about our daughters, well, they would tell us to come back tomorrow and then to come back tomorrow. I can be brave, but sometimes I just give in. I bend back. There comes a time when your brain and your body simply can't handle it anymore."

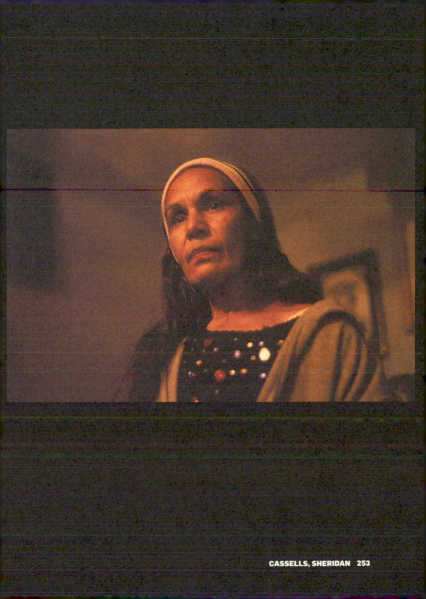

María de Jesús Diaz Alva
daughter Silvia Guadalupe Diaz

"Her name was Silvia Guadalupe Diaz. She was nineteen. She wasn't working. The day that it happened she was on her way to look for a job and then she never came back. I went looking for her everywhere. To the hospital, the Red Cross, jail . . . they never told me where she was. They don't care here. It only seems to happen to poor people. If it had happened to one of them, maybe the cops would actually do something about it. It's been nine years and they don't know who did it. Nothing. No suspects, nothing. They haven't caught any of the murderers of our people. That's why we're angry."

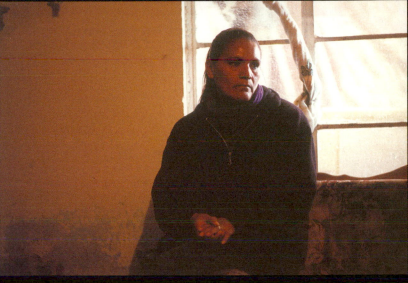

María de Jesús Ramos
daughter Barbara Araceli Martinez Ramos

"Barbara has been missing for five years. The government, when they campaign, they all talk about us and the women and this and that, but when they sit down on the chair, the fuckers are worthless. Baeza asked me why are you so angry? And I told him what do you care? Just pray to God that this never happens to your family. He said no, no. I would die. And I told him, well fucker, this is our life, every day! The doctor told me I needed to relax, told me that because of all the anger I had kept inside me I was about to die. I was almost a hundred kilos and lost thirty. The doctor told me that she didn't know why I was losing so much weight. I was worried that I was all broken inside."

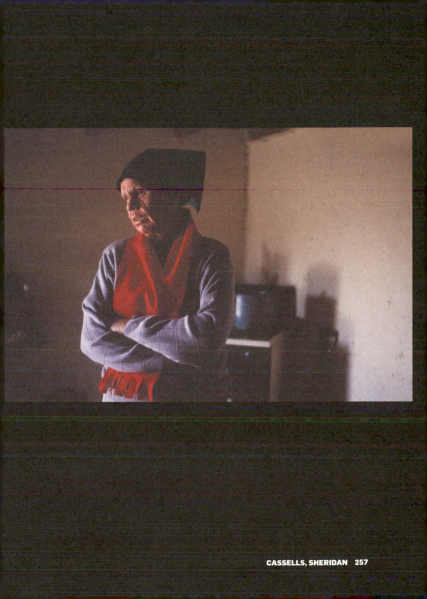

Martha Ledesma Hernandez
daughter Angelica Marquez Ledesma

"I ask God for strength, it's going to be eleven years. I know she's dead because they found her clothes. The cops burned the clothes and the evidence. God and the anthropologists, I have faith in both of them, because the police will not do anything about it. The media blames the girls for being murdered. They blame them for being bad women. I get angry because our girls were our girls and they were good. Angelica was fifteen years old. She disappeared on April 20, 1995. She disappeared around the maquilas in the Independencia neighborhood at 9 AM. She was in the neighborhood going to maquilas to ask for work. Four girls have gone missing in the same area. Poor people are nothing but poor dogs that have no rights to laws. Rich people do, because they have money. The rich people ignore us as if we were little animals. They don't understand our pain. It's not just the mothers, it's entire families that are permanently damaged and permanently scarred. Our entire family was damaged. Our son tried to commit suicide twice. It's very sad for them and for me. I can't control myself sometimes and I will not be able to until I find my daughter."

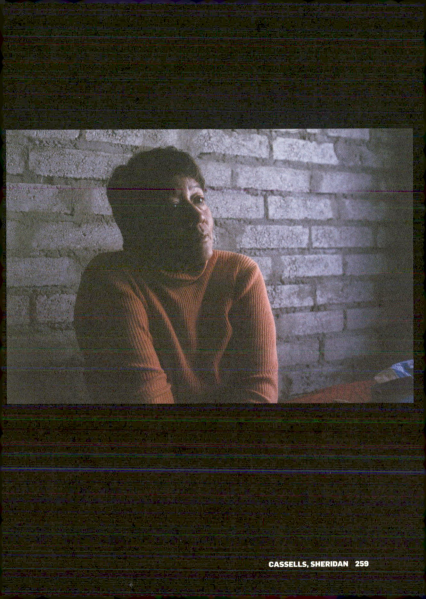

María Esther Luna
daughter Brenda Esther Alfaro

"There is incredible corruption in the government. If you have money you are worth something, if not you are worth nothing. Human rights do not exist here. Why they chose us is because this social class does not have a voice. Supposedly after the Mexican Revolution we were all equals, but it never changed. Our lives are worth nothing. We have no rights. Authorities and people with more money see us as low class, worthless. Murderers can do whatever they want with absolute impunity. Society sees our daughters as something within reach they can do whatever they want with. I wish people knew the truth. When my daughter disappeared, she was fifteen years old—the press completely trashed her. They said that she was on the street flirting with boys, looking for drugs and the 'bad life.' If a woman is from the wrong side of the tracks that makes her disposable, it makes her a ghost. That's what they shield themselves with to not start investigations. It's their excuse. In my case there was evidence that they trashed and destroyed. I would go to the station and demand justice. They would get angry: 'Here you are again! Why don't you just go home and shut up?!' At this point, the only justice I believe in is divine justice."

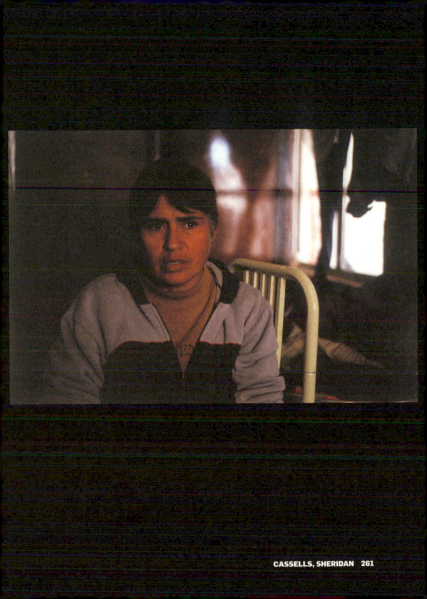

Lilia Irasema Mendoza

Daughter Miriam Arlet Velasquez Mendoza

"My daughter was kidnapped on a Saturday on her way to work an extra shift, but she didn't make it to the maquila. She was kidnapped between the bus and the factory entrance, but she wasn't killed or raped there. They took her and they raped her Saturday and Sunday, and on Monday they dumped her body. I had already heard that other victims had been dumped there, so I went to the factory and around it to look for her. I had lost my mind. I looked in ditches, I looked under bushes, I looked everywhere. I thought I was going insane, yelling her name out loud at two in the morning. I would look for her in ditches hoping to find her half-dead, but still alive, and I never found her. They found her in a ditch outside of the maquila where she worked.

They opened the doors to the morgue and the first thing I saw were her bangs. I thought to myself, 'that's my daughter,' and almost collapsed. Her clothes were all torn. It looked like they had torn them up with a knife. The pants and her underwear were pushed to the side and she had eight stab wounds–really big holes. It was horrible. But it was my daughter. That was her, that was her body. She was still so young."

Irma Monreal Jaime
daughter Esmeralda Herrera Monreal

"I know that it hurts differently for everyone, but for me I feel that an entire part of my life ended. Every day was a happy day with her. After what happened with my daughter, the music ended in my house. Everything ended. The body they said was my daughter was found after eight days of her being disappeared. When they found those bodies, hers was complete from the waist down but from waist up, there was nothing. It was just bones. There was no hair, nothing. She had a lot of hair and it was dyed blond. I must have looked crazy looking around Campo Algodonero for a single strand of blond hair so that I could know that this body they gave me was in fact my daughter's. When the bodies were found, no one told me. I found out about it through people from work who saw it on TV. We went to a police station and they told me to buy the newspaper because it would tell me more than they would. I left there crying, and we went to the morgue. We were led to one where you could see the outline of a girl's body underneath a sheet. I wanted to see the body but they said that I needed a warrant to see it, they just put a shirt and socks on top of it and asked me if I could recognize the clothes. It was my daughter's favorite shirt. It was all torn and covered in blood and grease. Her socks, they were two weeks old, they were new, but the ones that were there were all torn up, they were destroyed like the shirt. They were covered in blood like the shirt."

Maria Rosario Hernandez
daughter Eréndira Ivonne Ponce Hernandez

"My daughter is Eréndira Ivonne Ponce Hernandez. She disappeared in 1998, it's almost eight years now, and the investigation is going nowhere. There's a suspect but they have not issued an arrest warrant. I don't know why. I want justice for the killer of my daughter, first. Then—how the Bible says, that the rest will clear itself up. I want my case resolved, but I have lost faith. It's been eight years. If when they've just been killed they can't get justice, imagine what goes on when it's been so long? I have lost my daughter, and I have lost the case. A poor girl with no money; I think that the people that did this are beasts. That's how I refer to them. My daughter liked to play guitar and sing and work. She wanted to be a business major. She had a lot of dreams and she wanted to progress, to get ahead. These guys ended all of those dreams."

Rosa María Gallegos
daughter Rocio Barraza Gallegos

"Juarez used to be very peaceful, but now it's gotten really ugly. You could leave your windows open, now you have to lock yourself up, bars on windows, the whole thing. I remember when we moved here it was really relaxed. You could even trust cops. Now they stop somewhere near you and you have to run from them. If I am walking and suddenly I am stuck between cops on one side and a gang of thugs on the other, I would run towards the gang because at least they would kill you with more dignity.

My daughter was killed outside the police academy, in a police car, with a police gun by an agent who was part of the team in charge of investigating the murders and disappearances of women. He was the nephew of the commander of the police force; they protected him so that he could leave. He is in Mexico City working for the AFI (Agencia Federal de Investigación). We went there to talk to President Fox and I asked him: 'Can't you smell death when you visit Juarez? In all of your trips, haven't you realized what is going on? How can you reward someone that is a criminal in Juarez with a high-paying job here in Mexico City?'"

Victoria Salas Ramirez
daughter Guadalupe Ivonne Estrada Salas

"It wasn't only the murders of our daughters, it's the pain of knowing that the fact that we live in the hills and that we are poor families gives any person with money or power the right to come here and step on us, and not only step on us but murder our daughters. It's the truth. These people, these murderers, are not from the barrios. They are people with money: they are people that can buy protection. That means cops, everything. All of them are mixed up in it. They think that we are afraid of saying things because they have power and they think that their power can keep our mouths shut. I felt triumphant when I yelled at authorities and told them the truth to their faces. My head started to boil and all of a sudden, I had stood up for myself: for the first time, I realized, I felt that I had avenged at least a little bit of what they had done. A tiny bit, but a bit at least. They are never going to shut me up, and if they do shut me up by killing me, others will raise their voice in my name. We were all born to die, and if we die in battle we will have died a heroic death!"

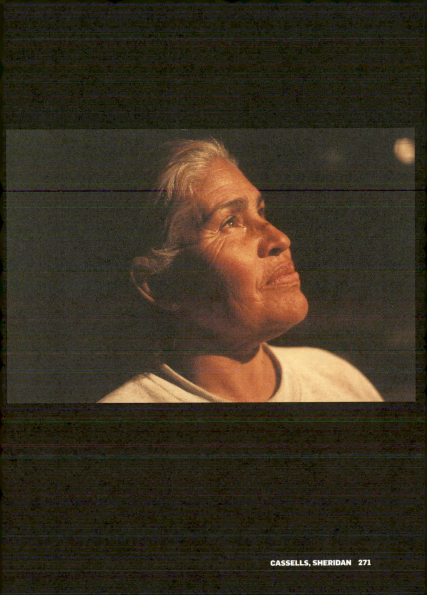

PLASTIKOS

Susana Reisman photographs
the vacuum-formed packaging used
to display consumer goods.

SLOUGH

A poem by Mani Rao explores
this corporeal premise:
"The new skins you grow are slough."

Slough must be eaten to the last shred.

On the last journey, tracks made by the head must be covered up by the body.

Coil to the shape of a bracelet, place tail inside mouth, fasten clasp.

Nude, the poet has to fashion masks out of his own diaphanous slough.

Extract expressions and adore each as a face.

There is no face, only a deft masker, spectral spectrum.

As shadow to body, body to rhythm—follow the ruse—this far—this guise, this guile.

The womb never leaves a child. You wear it on your back even as you look for it in absentminded mourning.

The new skins you grow are slough.

But this is flesh, kin.

Slide back into its canoe, bark curved from memory, and thus dressed, go to the shore of your bride of death.

CONTRIBUTORS

BARRY ALLEN teaches philosophy at McMaster University.

PIERRE BÉLANGER is a landscape architect at the University of Toronto.

EDWARD BURTYNSKY is one of Canada's most celebrated photographers.

RACHAEL CASSELLS is a photographer and is a contributing editor for *doingbird*.

Artist **NICK CAVE** is represented by the Jack Shainman Gallery, New York City.

PRIYA SARUKKAI CHABRIA is a poet and novelist.

ROBIN COLLYER is also one of Canada's most celebrated photographers.

SUSAN COOLEN is a Montreal-based visual artist.

REBECCA DUCLOS and **DAVID ROSS** are principals of Letheria International Plc. and collaborate under the name Graphic Standards.

KARILEE FUGLEM is a visual artist living in Montreal.

JENNIFER GABRYS is writing *The Natural History of Electronics*.

JENNIFER HARRIS teaches English at Mount Allison University.

GAY HAWKINS is the author of *The Ethics of Waste*.

WARREN HEISE draws pictures and designs graphics for books, games, and other fun stuff.

KRISTAN HORTON sees both the pie-plate and the UFO.

Artist **BRIAN JUNGEN** is represented by the Catriona Jeffries Gallery, Vancouver.

BILL KEAGGY is a collector, maker, and breaker of things (see keaggy.com).

TINA KENDALL teaches film and critical theory at Anglia Ruskin University in Cambridge, UK.

BRADEN KING is a filmmaker and photographer making new maps from images.

JOHN KNECHTEL founded *Alphabet City* in 1991.

NINA-MARIE LISTER talks trash in the School of Urban Planning at Ryerson University.

NYLA MATUK has written about shear keys, sealing wax, and silty sand.

MANI RAO can be found at manirao.net.

SUSANA REISMAN is a photo-based artist currently teaching in Rochester, NY.

LISA ROCHON is *The Globe and Mail*'s architecture critic and author of *Up North*.

HEATHER ROGERS is an independent journalist and filmmaker.

CAMILLA SINGH is assistant director/curator at the Museum of Contemporary Canadian Art.

ESTEBAN SHERIDAN is a Mexican writer and filmmaker tired of living in Texas.

ILONA STAPLES is a Toronto visual artist focused on food, consumption, and the body.

DEREK SULLIVAN is a Toronto-based artist represented by Jessica Bradley Art + Projects.

"**GARINÉ TOROSSIAN** is one of Canada's most original filmmakers."—*The Globe and Mail*

PRISCILA UPPAL is a poet and teaches humanities at York University.

TIGRAN XMALIAN is a filmmaker and philosopher living in Yerevan, Armenia.

EDITOR
John Knechtel

ART DIRECTION + DESIGN
The Office of Gilbert Li

MANAGING EDITOR
Jennifer Harris

COMMISSIONING EDITORS
Stephen Andrews
Daniel Borins
Heather Cameron
Mark Clamen
Karen Connelly
Roger Conover
Rebecca Duclos
Atom Egoyan
Dorothy Graham
Janna Graham
John Greyson
Mark Kingwell
Pamila Matharu
Joseph Rosen
David Ross
Natalie Shahanian
Jim Shedden
Camilla Singh
Timothy Stock
Kevin Temple
Sonali Thakkar
Ger J. Z. Zielinski

FESTIVAL COORDINATOR
Joe Liu

COPY EDITING
Doris Cowan

PREPRESS + PROOFING
Clarity

LEGAL REPRESENTATION
Caspar Sinnige

CONTACT
www.alphabet-city.org
mail@alphabet-city.org

Trash was published
with the support of:

THANK YOU
Gabriella Aviad
Jessie Caryl
David Christensen
Joshua Cohen
Danielle Curry
Davide Gianforcaro
Rick Hippolite
Catriona Jeffries
Marcin Kedzior
Deborah Kenley
Lisa Klimek
Melanie Kramer
Jimenez Lai
Kim Ligers
Zuleika Milan
Carla Munoz-Puente
Museum of Contemporary
 Canadian Art
Maya Przybylski
Thomas Smahel
Eryn Stoddart
James Totolo
Deanna Wasyliuk

NEXT ISSUE
Fall 2007
Alphabet City Magazine
no. 12: FOOD

DRAKE HOTEL
HOTBED FOR CULTURE

1150 QUEEN STREET WEST, TORONTO
416.531.5042 WWW.THEDRAKEHOTEL.CA

LETHERIA INTERNATIONAL, PLC

LETH IS MORE™

Alphabet City Media Inc. and
Letheria International plc
PROUD TO BE
WORKING TOGETHER
to bring enlightened reflection
and action to humanity's
urgent rubbish problem.

Our prestigious artifact
storage and redistribution
consultancy has been
assisting institutions to
discreetly manage surplus material culture since 1832.
Letheria International plc is globally recognized for their bold
investment in the Manchester Letherium, the world's most
advanced, accredited artifact dispersion facility. Sensitive to
all your deaccessioning concerns, Letheria International plc
will help you streamline your collections areas in an efficient
and responsible fashion.

"Letheria International plc devotes itself to the well-being of its partner institutions. In assisting cultural stewards to create legally and curatorially appropriate solutions for their surplus artifacts, Letheria International plc offers museums of all kinds nothing less than the promise of release from a burdensome past with all assurances of excellent care."

Gavin Plinth-Hughes
CEO

Because we all
know that
LETH IS MORE™

LETHERIA INTERNATIONAL, PLC

Letheria International plc
Oxford Road
Manchester UK M13 9LP

0161 225 7084
www.letherium.org